ARTS
and the
INTERNET

A GUIDE TO THE REVOLUTION

V. A. SHIVA

ALLWORTH PRESS
NEW YORK

Published in the United States by Allworth Press
an imprint of Allworth Communications, Inc.
10 East 23rd Street, New York, NY 10010

Cover by Douglas Design Associates, New York, NY
Book design by Sharp Des!gns, Holt, MI

Library of Congress Cataloging-in-Publication Data
V. A. Shiva Ayyadurai
 Arts and the Internet/V. A. Shiva Ayyadurai.—1st ed.
 Includes index.
 ISBN: 1-880559-40-4
 1. Arts and Internet.
 2. Technology and civilization.
 3. Computer networks—Social aspects
 4. Interactive media—Social Aspects. I. Title.

Library of Congress Catalog Card Number: 95-83009

Manufactured in the United States of America

to AMMA and APPA

who gave me great love and affection
which continues to provide me
with the confidence and strength
to pursue my dreams

CONTENTS

PREFACE

When Tad Crawford, the publisher of Allworth Press, and I met in the Summer of 1994, it was to discuss creating an Internet World Wide Web (WWW) site for Allworth Press. Many of my friends and I enjoyed the books that Allworth published because they were well written and of direct and practical use in both the visual and performing arts community. A web site for Allworth would not only create new audiences and markets for Allworth, but also would enable others to get to know the diverse range of books that Allworth publishes.

At that meeting, Tad mentioned that he wanted someone to write a book about the Internet and how it relates to the arts. I had been giving seminars in New England and along the East Coast on arts and the Internet. In fact, I had compiled a series of notes and writings on how the Internet could enable artists, arts organizations, and businesses to reach new audiences. Most of my efforts at Millennium Productions, the interactive solutions and strategies firm I started in 1993, were going into educating the art world about the Internet and technology—a challenging but rewarding task. Talking to groups of artists, art marketers, and performing arts managers, and fielding their basic

questions and concerns—ranging from technology to copyright issues—made me provide real answers to tough questions. In addition, I was forced to find ways of explaining technology and the Internet in the most easy-to-understand terms to those in the art world where techno-babble is frowned upon.

Based on that first meeting with Tad, we decided that I would write a book called *Arts and the Internet*. The book was to be a guide to the Internet that would empower those in the visual arts, performing arts, and writing community. We wanted to create a book that would not only educate the reader about the Internet but would also teach the reader that the Internet, the fastest growing communications medium in the world today, is a stage on which the creative trinity of art, technology, and business is brought forward. The goal of this book was to inform people in the arts that there is a *communications* revolution taking place and to inspire artists and the art world with the idea that they have a great deal to benefit by learning about this revolution and the tools that are available.

▶ 8

We did not want this book to be just another book on the Internet. There were already too many books on the market that raised more questions than they answered and made the reader feel even more helpless. The fundamental goal of this book, therefore, was to be inspirational and educational. I hope we succeeded.

V. A. SHIVA AYYADURAI
Cambridge, Massachusetts
June, 1996

ACKNOWLEDGMENTS

would like to thank Nicholas Negroponte, Director of the MIT Media Laboratory, and the late Jerome Wiesner for having the vision and confidence to create the Media Lab. The Media Lab was the first place in my life where I had the opportunity to express both my artistic and technological talents without feeling a need to justify one or the other. I was also fortunate to have worked with Muriel Cooper, the former Director of the Visible Language Workshop at the Media Lab, and Ron MacNeil who encouraged my research in developing intelligent agents and technologies for graphic design.

I am also grateful to Professor James H. Williams, Jr. in the MIT Engineering School, Department of Mechanical Engineering, for his influence on my life. He is perhaps one of the finest educators in the world today. He has set high standards for the clear and precise communication of both scientific and non-scientific information. I hope that this book, which on one level is a test of my ability to communicate advanced technology information to the arts, meets his standards.

I would like to thank Tad Crawford, the publisher of Allworth Press, for encouraging my writing of this book. His incisive comments and criticisms were key in developing and reformulating various chapters.

I would also like to thank two individuals who were key to my learning about electronic mail and pattern recognition and classification early on, while a junior in high school in 1979. Dr. Leslie P. Michelson introduced me to e-mail and offered me the chance to use his laboratory computers for the development of my first e-mail system. Dr. Swamy Laxminaraynan introduced me to the exciting field of pattern recognition and classification.

Special thanks to those individuals whose association created the experiences I needed to write this book. Those include Peter Spellman, David Calvo, John Howe, Michael Hennessy, Nathanael Pine, Ntozake Baako, Wendy Kaplan, Matt Silbert, Bruce Padmore, Matt Dunn, Geri Engberg, Brian Berry, Jack Blovits, Neil Devine, Robert Tamm, Patric Lacroix, Roland Westgate, Heidi Megna, Brant Wojack, Kelly Blozie, Robert Brown, Luanne Witkowski, Brad Dupee, and John Petrocelli. Many thanks to those whose contact and discussions served to formulate my ideas and thoughts including David Brown of Boston Ballet; Maida Abrams of Very Special Arts Massachusetts; Minda Logan of Alvin Ailey; Jim Fields of the Cambridge Multicultural Arts Center; Paul Rickett, Kyle Gjersvold, and Keith Rickett of Very Special Arts National; Dean K. Stein and Vicki Roth of Chamber Music America; Paul Sacksman of *Musician* magazine; Jon Aaron of the National Association of Performing Artists Managers and Agents (NAPAMA); Ken Romo of *Dance and the Arts*; Jim Keller and Lynley Fenchel at NETCOM On-Line Communications; and Professor Charles Cooney at MIT.

A very special thanks to John Bradley for his unyielding pursuit of truth and justice and his invaluable wisdom and advice. Also a very special thanks to my sister Dr. Uma Dhanabalan and my nephew Sivaji Dhanabalan for their great encouragement and support.

Finally, I would like to thank Zoe Helene. Zoe is perhaps one of the finest multi-talented artists in the world—on par with van Gogh and Rembrandt—who is tucked away in Cambridge, Massachusetts, waiting to be discovered. And thanks to my animal friends Shaban, Beastie, Landau, Wild Thing, and Diva for their companionship during late-night writing sessions.

INTRODUCTION

BAZAAR

G rowing up in Bombay, India, I came to love chaos and diversity. For those who think America is a melting pot, Bombay is an industrial furnace. Diverse religions, classes, castes, cultures, races, colors, and languages meld into a sensory bazaar that is unequaled. The view from our apartment offered a jolt to the senses. From the back balcony, I saw futuristic skyscrapers and modern buildings made of glass, metal, and state-of-the-art materials. Through the front window, I looked upon hundreds of huts made from twigs, grass, old tires, straw, mud, and wires.

Our neighbors were Jews, Christians, Hindus, Jains, and Zoroastrians. Sadhus and yogis meditated along the road. Transvestites, transsexuals, gays, straight men, women, and children walked hand in hand. Respect for all was the unwritten law. A simple disdain of someone's way of cooking, passed down through centuries, could easily start a riot. Being multilingual was also the rule and not the exception. At home, I spoke Tamil; in school, English; on the streets, Hindi; with friends, Maharati.

The streets were sensational and extreme. People walked. Others were pulled on rickshaws. Bicycles and Mercedes rode side by side. Beggars

crawled. Boeing 747s roared above. There were the distinct smells of roasting peanuts, scrumptious curries, the exhaust of diesel trucks, side-road pooris, and cow dung. The outdoor markets offered freshly squeezed sugar cane juice, goat brains, 24-karat jewelry, jack fruits, radios, vegetables, books, toys, and a wild assortment of foods. Women in colorful gold, blue, and red saris strode by women decked out in the latest Italian fashion. Men wearing the traditional Nehru jackets, white dhotis, and hats conversed with businessmen in Armani suits and jackets.

I have particularly vivid memories of shopping in the outdoor markets. These were not twentieth-century supermarkets. There were no neatly priced items, bar code readers, or check-out clerks. There were only the raw goods, the buyer, and the seller. One-on-one negotiations and haggling were the methods of purchase. My mother had implored me never to go to these markets alone. She said that it was common that young children were kidnapped and sold to jungle dwellers at these outdoor markets.

► 14 My love of jack fruits was greater than my fear of being kidnapped. As a five-year old, money was a rare commodity. On one occasion, I had six paisa (about a penny) in my pocket and went on a visit to the prohibited market. I came across a stand where jack fruit was being sold. The man at the stand wore a bright green turban and had a full-length pitch-black beard that draped far below his waist. He was quite the spectacle. Perhaps this was the guy that steals children, I wondered. He did, however, have lots of jack fruit. I saw one piece priced at ten paisa. I shouted out "two paisa" and received not even a motion from him. Having obviously underbid, I raised my offering price to four and got a cold, dark stare. Buying these fruits seemed to be as much of a challenge as picking them in the jungles. As I proceeded to walk away, he came back with a deep shout, "eight paisa." I kept walking. He shouted "seven paisa." I shouted back "six paisa." He nodded. I had struck my first deal—my first *interactive purchase.*

September to November are the months of the monsoons in India. There are hundreds of inches of rain—floods and mud are everywhere. In December, after the monsoons have passed, Bombay and the rest of India are lush and green. If you ever want to travel to India, December is the best time to go. Ironically, in December of 1970, on my seventh

birthday, we left Santa Cruz Airport in Bombay and landed at John F. Kennedy Airport in New York on a cold, snowy day. We had moved to the United States.

My parents moved to the United States not for personal financial gain and comforts, but to offer their two children new opportunities and a better way of life. Both my parents, unlike many immigrants, had fantastic careers and jobs in India. I am always touched when I think of the risks my parents took, and the sacrifices they made in leaving their families, their jobs, and their well-established livelihoods in order to seek a better life for my sister and me. Their attitude towards life instilled in me a burning desire to serve all life by developing my talents and skills.

In 1978, after nearly seven years in the United States, while a junior high school student, I developed one of the world's first electronic mail (e-mail) systems on a computer network connecting three major medical colleges. I was recognized by the prestigious Westinghouse Science Talent Search Award Committee for the development of that e-mail system. Looking back, I understand why I was given an award. The scientists and technologists on the Awards Committee knew more about what e-mail meant for humanity, back in 1979, than I had ever conceived.

15 ◄

Today, e-mail is a household word. E-mail, very much like the one I developed in 1978, is used on the Internet for communication between millions of people around the world. The Internet is not a computer network connecting just three medical colleges, like the computer network that I developed my e-mail system on. It is a computer network connecting millions of businesses, homes, universities, government agencies, individuals, and organizations in more than one hundred countries. The Internet offers a host of tools for communicating and sharing digital information. E-mail is just one of them. There are many other tools that the Internet offers, as this book will describe.

The Internet, developed by the United States government on advice from the Rand Corporation in the mid-1960s, has existed for over three decades. Why then has the Internet become a household world in 1996? There are two key reasons for the popularity of the Internet today.

First is the pervasive use of e-mail, with e-mail addresses appearing on many business cards alongside phone and fax numbers.

Second is the development of the World Wide Web (WWW), an

Internet tool developed in the 1990s by Swiss scientists to access and present multimedia information in a convenient and user-friendly manner.

The WWW is to the Internet what the first Macintosh was to computers. Without the need to know a lot of techno-babble and sophisticated use of computer hardware, the WWW enables access to information on the Internet at the click of a mouse. The WWW has created the foundation for users of the Internet to build their own "homes" or *web sites* on the Internet. A web site has a front entrance, known as a *home page*, and can have various rooms, *web pages*, containing pictures, text, video, and sound. Each web site has its own address, or *URL* (Universal Resource Locator), very much like a street address. By simply supplying a URL, a user can jump to any site on the Internet WWW in the world.

I can browse millions of web sites with the click of a mouse button. I can get as much information from the web site as the owner has made available. Many diverse groups and individuals have built web sites on the Internet. Religions, government agencies, political groups, artists, galleries, schools, and others (including dogs) have web sites on the WWW.

The cost of creating a web site and making that web site address accessible to the nearly 20 million people on the WWW is pennies compared to traditional means of advertising and communication. Thus, as many are saying, the WWW is "leveling the playing field." This means that a local recording artist in Arkansas has equal access to a web site as a major multi-billion dollar corporation. That same local artist, however, can forget about ever having a show on a major television network.

The WWW allows you and me to browse the Internet very much like browsing a bazaar, hopping from one storefront to another, but a lot faster since distance is now collapsed. From my home computer in Cambridge, Massachusetts, I now have access to a diversity of views, as I had from our apartment in Bombay. I can peer into multi-billion dollar corporations such as Disney, Sony, and Paramount; and I can, with *equal* ease, at the click of a mouse, listen to the works of a country singer in a small town in Billings, Montana. I can browse major art works in the Louvre in Paris, France, or look at African art at the Hamill Gallery in Roxbury, Massachusetts.

There are, as in the streets of Bombay, unwritten laws in the bazaar of the Internet. There are dos and don'ts. And such laws are not handed down from a centralized authority, but are organically developed by communities of ordinary people like you and me. While there are governing organizations, the Internet is fundamentally untamed, decentralized, and free. This is what makes the Internet so revolutionary.

Bombay, the Internet, and computing in general also have another similarity—population growth. The number of people in Bombay, the number of people on the Internet, and the number of people getting computers are growing exponentially. Over 40 percent of American families and over 50 percent of American teenagers own a personal computer. In 1994, more computers than TVs were sold to United States households. Today, it is estimated that over 40 million people are on the Internet; of this 40 million people, nearly 20 million people are on the World Wide Web (the graphical multimedia version of the vanilla Internet); 65 percent of new computers sold worldwide in 1994 were for the home; and 90 percent of those to be sold this year are expected to have modems and CD-ROMs. The population of the Internet is growing at a rate of 10 percent per month.

The Internet is spearheading a *communications revolution* where space and time are collapsed. Unlike the information revolution, which was about broadcasting information to as many people as possible, the communications revolution offers individuals the ability to have interactive multimedia communications across thousands of miles through many international time zones. This communications revolution is making it possible for disparate groups to connect and share knowledge and information as never before in history.

So, why am I writing this book? Why is this book entitled *Arts and the Internet*? You may say, Shiva, you have yet to mention anything about the arts! This book has been written as a guide for the millions of visual artists, performing artists, writers, directors, marketers in arts organizations, and owners of arts-related businesses who are seeking new avenues of promotion and opportunity using the Internet. In addition, there are three specific reasons why I chose to write this book.

First is to awaken you to the possibilities of what this communications revolution has to offer the worlds of art and technology. It has always been my feeling that these two worlds have been artificially separated.

God forbid that my fellow artists in high school ever found out that I won a prize in calculus or developed an e-mail system. How embarrassing! I would be called a nerd. It was not right to be *both* an artist and a computer or math jock. My high school soccer team would have laughed me off the field if they knew that I loved pottery and math.

History shows that at one time our art, our science, and our technology were all products of our day-to-day life. At some point in human development, art and technology were separated into distinct areas and stashed away in museums and research laboratories. Artists and scientists were often labeled different, weird, and crazy.

This disconnection has caused, and is causing, great harm in our world today. I believe that the Internet literally offers the potential for us to communicate in a global village as we once did many millennia ago. In this global village there is a fusion of art, science, technology, diverse cultures, religions, and politics.

Second, this book is written to teach, in a step-by-step manner, how to participate in the new global community and how to use this new technology to become more self-reliant. Many art forms do not require artists to stay abreast of current technology as it relates to art. But if you are serious about the arts, you cannot afford to miss out on the exposure, marketing, and sales potential of the Internet. This book will teach the basics as well as more advanced techniques for utilizing the Internet.

A friend of mine once said that New York has more entertainment lawyers per square foot than pigeons in Central Park. In the contemporary art and entertainment world, the statement "It's who you know" is the secret of success. Agents, lawyers, art consultants, and gallery owners have made their livelihoods on this paradigm. Many of my friends are musicians, painters, and writers who are all still looking for their *big break.* My friends and other artists will need to redefine what it means to make it.

On the Internet, it's "who knows you." People make connections with other people every day without any gatekeepers. A friend of mine, a visual artist, learned how to use the Internet to market herself. Within six months, 15,000 visitors came to view her artwork at her web site. She said, "More people have seen my art work in the past six months than in the past six years." She could never had gotten such exposure in the traditional venues of galleries and shows.

Third, I wrote this book to let you know that there are fundamental issues being raised which will change everything as we know it. Issues of copyright, intellectual property, security, and censorship will force us to redesign our lives, rethink national boundaries, engage in multi-cultural activities, and question our current economic systems. In the midst of these changes, however, lie vast new opportunities for artists. Distance learning and collaborative art, for example, can be used to teach art and create art without leaving one's home. There is going to be an explosion of job opportunities for artists. Who is going to design the web sites and virtual reality (VR) interfaces of the future? Who is going to create the sounds, the movies, and the backdrops of the landscapes of cyberspace? Artists.

Before I began writing this book, my goal was to write the most readable book, without techno-babble, to teach you how to use the Internet. However, during the course of writing the book, something happened. I began to realize that the Internet needed the arts more than the arts needed the Internet. The Internet, after all, is just another tool that artists can use. However, communications tools and technologies, including the Internet, do not ensure true communication.

19 ◄

True communication is a dance with the divine and is, at the core, an exploration of the self. Artists attempt to communicate at this level every day. Without the creative energy of the arts, the new communications revolution will yield a society that will be an even larger cultural wasteland. Although the Internet is a fantastic tool, art must come first. Thus the name *Arts and the Internet*. Remember, the Internet is the fastest growing communications medium in the world today. What kind of communication and communication revolution will we have without the creative energy of the artist? Just explore some the web sites on the WWW. There is a lot of cyberspace junk. Many of these early web sites were developed without any sense of design, color theory, interactivity, and the like. The Internet needs the arts, and the Internet offers a golden opportunity for artists.

I am writing this book, therefore, to ask you to join this revolution. I am writing this book to give you the tools, so that you will participate in order for us to have a true communications revolution. A new way of life is being created. If artists do not participate in this new way of life, there will be an empty, lopsided world that is even more divided.

. .

Fortunately, artists are tuning in and taking advantage of cyberspace every day. And many artists are learning to use the computer and software tools needed to build and design web sites.

Technology is increasingly becoming a commodity. New gadgets and devices are being created every day. Technology will enable me, in the next decade, to telecommute with ease to distant places and time zones. Today, using the Internet from my home, I can take an online drawing course from a master painter in Minneapolis and work on a collaborative digital art work with hundreds of artists throughout the globe. Tomorrow, I will be able to look out my window and see ten thousand miles, and twelve time zones away to my home in Bombay and revisit its sights and sounds. And perhaps, you will tune in with me, and we will come across a merchant in a bright green turban with a long pitch-black beard selling jack fruit.

REVOLUTION

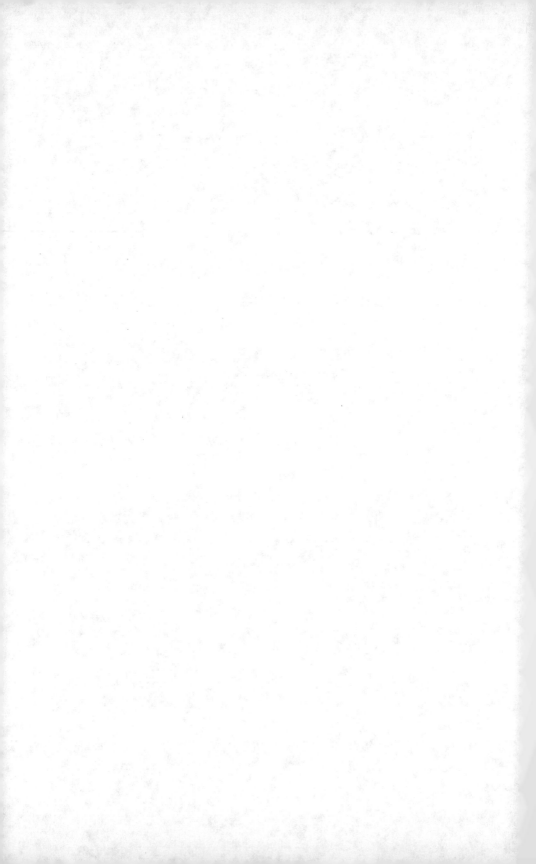

STATE of the ART

rt, technology, and business are partitioned into separate and distinct activities. This separation is maintained and controlled by gatekeepers who profit by being the agents of communication and connection. Many artists who struggle to get their work known and discovered wait for the "big break" offered by gatekeepers. And these gates often open to jobs and opportunities that co-opt the artists' real reasons for pursuing their art in the first place.

SEPARATED AT BIRTH

Young children and babies make us remember who we are. Our neighbors have a two-year old baby girl named Neena. When music is on, Neena begins to dance and create her own steps and moves. No one taught her. When she's not dancing to music, she's always playing with some toy or stuffed animal. And, on a few occasions, I have seen her thinking about how to get away with not eating her vegetables. In addition to being a playful and creative being, she is definitely a thinking being.

To most, the words *Homo sapiens* mean human being. Homo sapiens in its literal sense means *thinking* being, one aspect of being human. Few

have heard the words *Homo ludens* and *Homo faber* used in reference to human beings. Why? Homo ludens refers to *creative* being, another aspect of being human. Homo faber refers to *playing* being, yet another aspect of being human. The terms Homo sapiens, Homo ludens and Homo faber, together, are perhaps a more comprehensive definition of human beings.

We are thinking, creative, and playful beings. Our "primitive" ancestors were complete human beings. Our ancestors did not separate and distinguish between the acts of thinking, creating, and playing. These activities were part and parcel of their daily lives. Songs were sung while gathering fruit; paintings were created on caves to commemorate the hunt; dancing was used to enjoy the harvest. Strategizing for a hunt, playing in the fields, or creating tools, were seamlessly woven into day to day activities of life.

There was no distinction between artist, technologist, or businessman in primitive societies. Such job distinctions did not exist because there were no class and task divisions. The hunter, toolmaker, gatherer, strategist, dancer, and poet were one person. Poetry, dance, painting, music, and sculpture, moreover, as historian and sociologist Roy McMullen observed, "merged and were dedicated to magic, religion, ancestors, survival and social cohesion."

At some point, we, as society, literally lost our childhoods. Our creative, thoughtful, and playful parts were separated and made alien to our daily lives. Thus emerged the artist, the scientist, and the businessperson, as distinct roles. This separation seems to have taken place at some time in our evolution, when the ownership of property occurred and when human beings began to develop the notion of *class*. As soon as human beings became *class-conscious* and saw themselves as workers, peasants, priests, or aristocrats, their minds, hearts, and hands drew apart. Our labor, the activity of daily life, which once thoughtful, playful, and creative, lost its multi-dimensional characteristics and was partitioned into separate and distinct activities.

The industrial age went further in causing separation and boundaries. The original fusion of art, technology, and business was distilled into distinct and separate activities to make mass production more efficient. It became profitable to have a labor force which was specialized. Art was reserved for the few to "appreciate" in private collections, galleries, and

. .

museums. Scientists and technologists were placed in the ivory towers of academe and research laboratories. Business people could be found in their boardrooms and backrooms.

Today, the state of the art and the artist is such that we have artists with technophobia. Disdain and fear of technology is the rule and not the exception in the arts community. Technologists and scientists, meanwhile, are not taught to have regard or respect for art. Art is seen as kids' stuff, for the simpleminded, a leisure activity at best. Both artists and technologists, furthermore, know little about business and get exploited every day.

To the ordinary individual, artists are often portrayed as weird, wild, or crazy by the mass media. Technologists and scientists are portrayed as nerds, geeks, and absentminded. In fact, I have seen many of my friends in both the arts and technology consciously cultivate oddities and idiosyncrasies to legitimize their activities as an artist or technologist. When I was a freshman at MIT, Professor Patrick Winston, one of the world leaders in the field of artificial intelligence, taught a class titled *How to Teach*. In this two-hour class, he ended by saying that it is important to develop a habit or a peculiarity if you want to be a successful professor. While he was saying this, he wrote with his right hand and erased what he was writing with his left hand.

The artist and technologist, both very creative, have been separated from the daily activities of life. This division is deep. Communication between these diverse yet fundamentally creative groups is rare. C. P. Snow, literary author and scientist, was perhaps one of the few who bridged both worlds. He observed that he never understood why artists and scientists were in "two cultures" because he felt that they had much more in common than they had differences.

The division between art and technology is but one manifestation. The world today has many other divisions: nationality, class, race, color, religion, and more.

GATEKEEPERS

Division serves the needs of the one who divides. I grew up in a land that until 1947 was under colonial rule. Britain and other colonialist powers learned how to divide and rule. Prior to the coming of the British in 1657, the caste system was actually on its way out in India. The British

consciously resurrected the draconian caste system of pre-ninth-century India because it served to create a stratified and controlled populace where everyone knew their place. The resulting social divisions created distrust and ignorance, two powerful mechanisms of control.

In the modern world, we still have divisions by race, caste, class, etc. A few are on top and the majority are either struggling to be on top or have given up hope. *Gatekeepers* are the ones who continually profit from these divisions. They are the agents of communication and connection. They serve, at best, as the bottleneck between those struggling to get somewhere and those who have gotten somewhere. They serve, at worst, to create the illusion that they are necessary for one's advancement and to destroy self-reliance and create doubts about one's abilities.

Gatekeepers developed the passports to cross national boundaries. Passports, however, are a relatively new phenomenon. I once met a cab driver who played the Iranian sitar. I had never heard of an Iranian sitar. The Iranian sitar is about two feet in length. I had thought that the sitar was an Indian instrument. He informed me otherwise. Apparently, almost a millennium ago, an Iranian scientist traveled freely, without the need for passports, from Iran to India. Arriving in India, he worked with an Indian musician to create a larger version of the Iranian sitar so that it could be heard in large concert halls. The result was the creation of the popular Indian sitar, which was eight feet in length. Such free communication between an Iranian scientist and an Indian musician gave the world a new instrument.

The Internet has no passports or gatekeepers. As I've said, in the modern art and entertainment worlds, where gatekeepers abound, the rule of thumb is "It's who you know"; but in the world of the Internet, "It's who knows you." Individual: such as entertainment lawyers, gallery owners, performing arts agents, and others, when playing the role of gatekeepers, victimize the arts by becoming the bottleneck between the artist and the public. I want to emphasize the phrase, *when playing the role of gatekeepers.* Many of these individuals, however, can play healthy and effective roles for the arts and society if they begin to see themselves as information specialists and advisors who can organize and provide information.

For many gatekeepers, the Internet is a death knell. For many major artists and emerging artists, the Internet is a new beginning. Major

recording artists who have established name recognition, for example, will not need their record distribution companies. David Bowie is thinking about not renewing his contract with his distribution company. Record companies, no doubt, are concerned. He is getting ready to use online resources to distribute directly to his established clientele. Writers and authors, who have established names, can also directly post their articles on their own web sites. They could, for example, charge a fraction of a cent for each reader who visited their web site. If you work out the math, publishers and newspapers should get concerned or think about increasing the pay scale of their famed writers.

For the emerging artist, who is attempting to develop a clientele and audience, the Internet offers techniques for creating an audience base and building name recognition in niche markets. Given that there are literally millions of people on the Internet each day, the chances are greatly increased that someone, even accidentally, will find your web site. Through effective cybermarketing or *cyberpublicity*, an emerging artist can develop a loyal fan or customer base. We will discuss how to use cyberpublicity in the chapters ahead.

27 ◄

Fundamentally, the Internet offers a golden opportunity for artists. Through the Internet, any artist can reach a viewing audience that, up to this point, could be only reached by showing at big-city galleries, performing at major concerts, advertising in expensive magazines and newspapers, or having articles in those same publications. Any art form, be it visual, performance, or written, will benefit from the use of the Internet and the WWW.

The Internet will force the gatekeeper business to redefine its role to become one of providing information. *TV Guide*, for example, makes more money than all the networks put together, because *TV Guide* gives information on information. Galleries could give cogent, critical information on artists so the public could explore and purchase art more intelligently. Such activity by galleries may actually help the declining art market worldwide by creating an educated public which could become the future buyers of art. Performing arts agents and managers should do the same. Jon Aaron of Aaron Concert Management has taken this approach. He now displays biographies, reviews, audio clips, and video clips of the artists and groups he manages at his web site. Such information is a service to potential clients who want to learn as much

as they can before hiring an artist. Furthermore, it cost him very little to place that information on the Internet. Jon Aaron, who is also the President of the National Association of Performing Arts Managers and Agents (NAPAMA), is now encouraging other members of NAPAMA to get online and use the Internet to promote their artists.

Gatekeepers are not limited to the physical world. Other online services such as America Online (AOL), Genie, Delphi, Compuserve, Prodigy, and Microsoft Network are attempting to monopolize information content. They have set up toll booths for accessing that information at a per-hour charge. However, it appears that their model is failing because most users on these services are clamoring to get access to the Internet. Another gatekeeper, Bill Gates, seems to be backpedaling from his previous plans to build Microsoft Network as his challenge to the Internet. Gates has decided to accept the Internet as a reality and is now building Internet software to compete in the fast-growing Internet WWW market. The sheer growth and momentum of the Internet is challenging the business models of the established online services.

▶ 28

THE ROLE OF THE ARTIST

The role of the artist in today's world falls into two categories: solo artist/small-business person; or major national or international celebrity. The vast majority of artists fall into the first category. A few, one in a million, fall into the second category. Given this scenario, many artists strive to find ways to "make it"—reach celebrity status and attract mass audiences. Artists in the second category rely on gatekeepers and the mass media advertising machinery to promote and to maintain their celebrity status. What is ironic is that many artists from the first category work and sell their art to the advertising machinery which creates the celebrities they so want to become. Thus the role of the artist in modern society, by and large, is to support the patronage of the arts by big business interests in one form or another.

The consumerization of art through advertising has warped society's view of art and the artist. Artists, often gifted in their sensitivities and sympathies to the human condition, have been asked to use those sensitivities for manipulation. These sensitivities have also caused internal conflict among artists who struggle between their physical need to make money and their soulful interests to protect their art from

consumerism. Ex-ad men such as Sherwood Anderson, Wallace Stevens, and James Rorty, in their non-commercial writings, echo a sense of artistic strangulation that capitalistic patronage of the arts has produced. Anderson decries the advertising machinery which he states has effected a "dreadful decay of taste and the separation of men from the sense of tools and materials." Rorty further denounces the whole system of commerce that takes advantage of "the organic cultural life and then disintegrates and consumes, but does not restore or replace." These statements express the anguish felt by the artist whose art has been conscripted and deformed.

I have come across many artists who have great talent but have always felt a similar conflict between doing art and being co-opted in doing their art by market forces and consumerism. Zoe Helene, a gifted multimedia artist, recently had a series of events that forced her to face such conflict. She is well-trained and has attended some of the finest schools in the world for both fine arts and theater. At sixteen, she was selected by Disney as one of their youngest animators. She was praised by some of the finest directors and designers who had worked on Broadway. They said that she was "one in a million" and predicted that she would go far. However, after realizing the "real" nature of the entertainment industry, she eventually walked away from all of it. She forced herself to redefine the concept of "making it."

In early 1994, she took to the Internet and developed her own web site. Her web site showcased her music, fine arts pieces, modeling photos, and graphic designs. She received great exposure from this web site. She did not owe anyone anything for it. In 1995, *Playboy*, in its search for Internet Girls of 1996, selected her from five thousand women, after seeing her work on the WWW. What a conundrum! She did not want to become part of the machine. Now *Playboy* was knocking at her door. Many of her friends said, "Just do it. It will help your career." In the end, after a struggle, she chose not to. Another artist might have made a different decision. The point is that artists like her, and women especially, have to make such decisions every day.

The Internet offers artists a vehicle for getting mass audiences and exposure independently and at their own pace. An artist can attain "celebrity" status through the Internet, but not through reliance on some massive advertising machinery. The medium of the Internet and its tools,

as you will see, is *leveling the playing field* of communication. An emerging artist has as much access to a global audience as a major celebrity or corporation. This leveling of the playing field will enable artists to redefine their roles and to rethink what it means to make it. The first step needed to redefine and to rethink those roles is to gain a solid understanding of what the Internet really is and why it is an instrument of change.

INSTRUMENT of CHANGE

deas and thoughts are valuable, but significant change can only take place with the development of new and powerful tools and the understanding of how to use such tools. The mass media has done a great job in making *Internet* a household word. Yet, few really know what the Internet is and why it is so important. In my experience, I have discovered that when someone understands what the Internet is and, in particular, where it came from, they immediately realize it is a powerful instrument of change.

THE URGE TO COMMUNICATE

In 1981, I entered MIT as a freshman. In addition to overloading myself with courses, I also participated in a research project on *Tadoma* at the MIT Speech Recognition Laboratory. Tadoma is a fascinating way that deaf-blind people can communicate. In Tadoma, deaf-blind people "listen" to speech signals using their hand. The palms and fingertips of the human hand have more sensors per square inch than the retina of the human eye. The hands, in this sense, can "see" better than the eyes.

In Tadoma, one deaf-blind person places their entire hand on the other person's face and "listens" to the air flow, upper and lower lip movements, vibrations, and tongue position as the other person speaks.

Incredibly, the deaf-blind individual is able to make sense of what is being said. For me, I learned a great deal from this research. The most important research result was more philosophical than scientific: human beings have a deep urge to communicate and will use any resource and faculty for such communication.

In spite of our history, our laws, great walls, and barriers, the urge to communicate dominates our desires. Many experts said that the Berlin Wall would never fall. Many felt Russia and the United States would always be at odds. They were proven wrong. In spite of our many problems, I am optimistic that this desire to communicate will be the saving grace of humanity. I also believe that this urge to communicate globally has manifested itself through the creation of the Internet.

HISTORY

Where did the Internet come from? And what is it? The answers to these two questions are central to understanding the real nature of the Internet and its significance in modern communications.

► 32

In the early 1960s, the United States government was moving forward in its cold war activities. Communism was the enemy; the Soviet Union was evil; anyone who collaborated with the Soviet Union was bad; and only America stood for democracy. Mass media served to broadcast thirty-second sound bites and images to support this policy of antagonism and distrust. American citizens who communicated with Russia or sympathized with communism were alienated and called un-American. The cold war was a time of discouraging communication and putting up barriers between East and West, North and South. The United States Department of Defense worked day and night to prepare for war. They set up an elaborate system of command and control for the generals and the politicians to hide in mountains, and to communicate and survive in the midst of a major war or nuclear holocaust.

In early 1964, someone in the United States Department of Defense came to the eye-opening realization that a single bomb could effectively eliminate any form of command and control between the Pentagon and military installations around the world. The Rand Corporation, a major consulting company and think tank for government and industry, was called in to solve this problem.

In August of 1964, the Rand Corporation, after in-depth study of the

command and control setup of the United States Department of Defense, published a series of eleven papers called *Distributed Systems*. In these papers, the Rand Corporation recommended the creation of *peer-to-peer* communications, and a *message passing system* code named *hot potato*. They said that with peer-to-peer communications and message passing, the command and control of the United States would survive in the event that a massive thermonuclear blast destroyed the Pentagon.

Peer-to-peer communications? Before we can understand this, we need to understand the *boss-to-peer* communications system. The Pentagon, at the time, had a boss-to-peer communications system. Boss-to-peer communications can best be described by the illustration in Fig. 1.

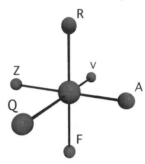

In the structure shown in Fig. 1, the Pentagon, in the middle circle, was the boss and at the center of all command and control communications. The middle circle was connected to a set of nodes, or

Fig. 1. Boss-to-peer communications.

33 ◄

peers, represented by the circles on the outside. This boss-to-peer system was analogous to a "hub and spoke" system of a wheel. If you take out the hub, the whole wheel falls apart. If the Pentagon, the hub, is destroyed, then no communications are possible between from any of the nodes at the end of each spoke. For example, a message from Site A, such as "Are you alive?" destined for Site Z, would never be communicated once the Pentagon was destroyed.

PEER-TO-PEER

Rand suggested peer-to-peer communications, or distributed communications, in which there was *no* boss. The new system would be composed of peer-to-peer interconnections that put no single system in charge. If the old system was wheel-like, the new system was sphere-like, in which every node was connected to every other node and to the Pentagon center through multiple links. Peer-to-peer communications is best illustrated by the diagram in Fig. 2.

Under this new system, you cannot destroy the system of communication by bombing its hub, the Pentagon. In this system, even if the

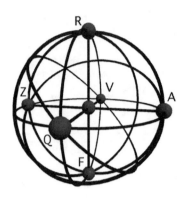

Fig. 2. Peer-to-peer communications.

Pentagon is bombed, a message from Site A can still be relayed to a Site Z by several alternate routes. Consider again the message "Are you alive?" Peer-to-peer communications offers several routes for this message to be passed including: from Site A directly to Site Z, from Site A to Site Q then to Site Z, or from Site A to Site F to Site Q to Site Z. There many other combinations. Thus, in a war scenario, it becomes virtually impossible to stop this message from reaching its destination.

MESSAGE PASSING: PACKET SWITCHING

As I mentioned before, Rand not only made recommendations for peer-to-peer communications, but also for the implementation of *message passing*. Message passing was developed to ensure speed in the communication of a message from one site to another.

Message passing takes advantage of peer-to-peer communications by offering a *protocol* or set of rules for breaking up the message into pieces and then reconstructing it. In this case, the message "Are you alive?" could be broken into the words, *are*, *you*, and *alive*. (We ignore the question mark.) Now using a message passing protocol, the word *are* may be sent along the direct route Site A to Site Z; the word *you* may be sent directly along the route from Site A to Site Q to Site Z; and the word *alive* may be sent along the route from Site A to Site F to Site Q to Site Z. The message passing protocol ensures that when *are*, *you*, and *alive* appear at Site Z, they are magically reconstructed to form the original message "Are you alive?"

Why all the trouble? The reason for message passing is to ensure speed regardless of the traffic along any one route. Using message passing, *packets* of the message are broken up, routed, and *switched* along different routes in the most expeditious manner. This message passing protocol came to be formally known as *packet switching*.

In 1969, packet switching was fully designed and implemented by Bolt, Beranek and Newman (BBN) under a contract from the United

▶ 34

States Defense Department's Advanced Research Projects Agency (ARPA). Also in 1969, an experimental network was created that incorporated both peer-to-peer communications and packet switching. This network was called ARPANET. ARPANET was the beginning of the Internet. It was conceived by Bob Taylor, the director of computer research at ARPA. In addition, many other people, including Charlie Herzfeld, Larry Roberts, Vinton Cerf, Jon Postel, Steve Crocker, Bill Naylor, Doug Englebart, and Roland Bryan were key contributors to the building of the ARPANET. These people were at ARPA and were the heads of the early node sites (e.g. Site A, Site B, etc.) such as Stanford, SRI International, and University of California at Santa Barbara.

ARPANET was a government-funded research project. The original networked sites were military bases, universities, and companies with defense department contracts. As the size of this experimental network grew, so did concerns for security. The same networks used by companies and universities for military contractors were becoming more and more accessible to the public. As a result, in 1984, APRANET split into two separate but interconnected networks: one for military use and one for educational use. The military side of the network was called the MILNET. The education side was still technically called ARPANET, but became more commonly known as the *Internet*.

The Internet became a high-speed electronic transportation mechanism, linking key sites at government agencies, defense contractors, colleges, and universities. But other independent networks were also in development. Soon, many of these independent networks began seeking permission to connect themselves to the high-speed lines, or *backbone*, of the network of the Internet. Thus, the Internet grew to become a *network of networks*.

In 1990, ARPANET was formally dismantled, but hardly anyone noticed because by then the Internet had become independent of ARPA. The Internet, with peer-to-peer communications and packet switching, stood on its own two feet and became an organism which was more than the sum of its parts.

In 1991, the Internet, which had already become a network of networks, became available to ordinary citizens. More colleges, companies, individuals, artists, and government agencies hooked up to the Internet. The Internet ceased to be a network dedicated to the

purpose of defense. It became a global communications medium open to the general public.

Thus, the Internet, a network accessible to the general public for global communications, developed from the need to protect and insulate the United States from attack by foreign powers. Ironically, engineers and scientists, who had used their talents to create weapons, created an instrument for global communication. Professor Melvin Kranzberg, one of the world's pioneers in the history of science and technology, commenting on such ironies, once wrote: "Engineers, in general, live in the suburbs, vote Republican, and mouth the clichés of conservatism. Actually, if unwittingly, they are greater social revolutionaries than many wild-eyed political radicals. Without necessarily meaning to, they invent new products, processes, systems and devices that produce profound socio-cultural transformations." His statement epitomizes the irony in the creation of the Internet.

TCP/IP, SLIP, AND PPP: WHAT ARE THEY?

► 36 In the context of the previous discussion, you are now well equipped to understand the terms *TCP/IP*, *SLIP*, and *PPP*. As you recall, the Internet is composed of peer-to-peer communications and packet switching. Recall, as well, that packet switching is a set of rules, or *protocol*, for passing messages on the Internet. TCP/IP, SLIP, and PPP are the names of the actual protocols for passing messages. That is all they are. So when you hear someone throwing around these terms, don't be afraid. They are just a bunch of rules, which have been translated to computer format (software). When you get an Internet connection, you will be using the software that makes use of TCP/IP, SLIP, and PPP. The difference between the three protocols is the kind of network they run on.

TCP/IP stands for *Transmission Control Protocol/Internet Protocol*. It is the protocol used for packet switching on high-speed lines and networks. SLIP and PPP stand for *Serial Line Interface Protocol* and *Point-to-Point Protocol*, respectively. SLIP and PPP were developed for use on modems so that a home computer could *slip* into the Internet.

INTERNET PROTOCOL ADDRESSES
AND DOMAIN NAMES

TCP/IP offers the services of *Internet Protocol addresses* and *domain names* to keep track of every computer on the Internet. Every machine that is connected to the Internet via TCP/IP has to be uniquely identified. Without a unique identifier, the network doesn't know how to get messages to your machine. If there is more than one machine with the same identifier, the network doesn't know where to send the message.

The Internet identifies computers on networks by assigning an Internet Protocol, or *IP*, address. IP addresses are often four numbers separated by three periods. For example 212.186.4.4 is the IP address of a machine on the Internet. In one sense, every computer on the Internet is "just a number." Whenever a message is transmitted between two computers anywhere on the Internet, one IP address refers to the computer sending the message and the other IP address refers to the computer receiving the message. Without IP addresses, communication on the Internet would be impossible.

Fortunately, for end users like ourselves, we do not have to know and keep track of IP addresses in order to send and receive messages. The *domain name* system of the Internet resolves this problem by assigning an English-like name called the domain name to the IP address. All Internet sites, therefore, are identified by a unique domain name. The domain names are made up of two pieces of information separated by a period. The first piece of information is an identifier unique to the organization or company. The second part, called the *domain identifier*, comes after the period. There are six domain identifiers established by the Internet Network Information Center (InterNIC). They are:

37 ◄

DOMAIN IDENTIFIER	MEANING
.arpa	An ARPANET identification
.com	Commercial company
.edu	Educational institution
.gov	Any government body
.mil	Military
.net	An Internet access provider
.org	Non-profit agency

All of the domain names have one of the six domain identifiers listed above, unless they are based outside the United States.

Some examples of domain names are *cbs.com*, *mit.edu*, *nasa.gov*; these domain names are for the broadcasting company CBS, the educational institution MIT, and the government agency NASA, respectively. When an institution connects to the Internet, it must register its domain name with InterNIC. Domain names, like IP addresses, must be unique to avoid confusion.

SEVEN INTERNET CONCEPTS

The Internet is the fastest growing communications medium. Those who choose to use it need to be aware of the nature and conditions of this new cyber-landscape. Now that you have learned the history of the Internet, what peer-to-peer communications is, how packet switching works, and what domain names and IP addresses are, you are ready to appreciate the seven key concepts of the Internet.

The first concept is that the Internet is not an end. It is a means. Physically, it is like a highway. It is the transport mechanism, not the destination. The Internet links millions of computer sites together, so you can travel on it to send and receive information from one site to another.

The second concept is that the Internet creates a *oneness* of each site or location in both time and space. Every node or site is equal because of peer-to-peer communications. Space and time give way to a communications medium that equalizes distance and spans time zones. Sitting at a computer in an artist's loft in the South End of Boston, you can pull information from a computer located in a studio in Chile in one second and then switch to view other information from a computer located in a gallery in Finland in the next second.

The third concept is that the Internet is under no one's control. It is true that until now, in the United States, our tax dollars provided the bulk of funding for the backbone links. But now the Internet has taken on a life of its own. If the United States government were to completely withdraw its support tomorrow, the effect on the Internet might be the equivalent of a nuclear blast. The Internet would still survive! And that's precisely what it was designed to do.

The fourth concept is that the Internet has community standards. These standards are organically developed without the dictates of a

central authority. This feature of the Internet will help to solve many of the more ambiguous issues of copyright, censorship, and security as opposed to some top-down mandated government regulation. Just like the "Wild West," there are unwritten laws. Those who violate the unwritten laws are *flamed*, or subject to harsh criticism via e-mail and public forums. Marketing and promoting oneself on the Internet requires an intimate understanding of this concept.

The fifth concept is that the Internet is people-based not government-based. No government committee in Washington, DC sat down, for example, to create and implement the concept of *newsgroups*. Someone on the Internet came up with the idea of sharing ideas on a particular topic, a newsgroup, via a system where all messages are saved one after the other for others to read. Today, there are ten thousand newsgroups with participants worldwide.

The sixth concept is that the Internet is blind to race, color, caste, creed, and the like. In one issue of the *New Yorker*, there is a cartoon that shows a dog sitting in front of a computer screen with its paws on the keyboard, saying to another dog nearby, "On the Internet, nobody knows you're a dog." Well, on the Internet, nobody knows your name, age, gender, or nationality. All they know is what you say and what digital work you choose to show. The ingrained prejudices that many bring to any human encounter are greatly reduced in this medium.

The seventh concept is that the Internet is its own culture. Some call it a *cyberculture*. Just as someone traveling from the United States to France would respect and regard the ways of the French, so should those traveling in *cyberspace*, a term generally used today to refer to the Internet, respect the culture of the Internet.

THE WORLD WIDE WEB

The Internet, remember, is not the end but the means. There are various tools which help you to take advantage of the Internet. Among them are e-mail, newsgroups, mailing lists, File Transfer Protocol (FTP), Archie, Telnet, Internet Relay Chat (IRC), Gopher, WWW browsers, WWW search engines, and WWW directories. These are the various tools that allow you to communicate, find information, and share information with other computers and sites. In the next chapter, "Tools for Revolt," we will explore each of these tools in detail.

For now, the important thing to understand is that the reason you are reading this book today is because of the development of the World Wide Web (WWW). The WWW did for the Internet what Macintosh did for the computer. The WWW made the Internet accessible to the masses. Remember that the Internet has been around for nearly thirty years, but the reason for its explosive growth is because of the WWW.

What is the WWW? Is it another network like the Internet? Or is it a piece of the Internet? Neither. The WWW is, above all, a method. Yes, a method. It is not a network; it is not a piece of the Internet.

The WWW is a method or way of organizing information and files on the Internet. In the 1990s, a group at CERN, the European Particle Physics Laboratory in Geneva, Switzerland, developed this method. They said that the WWW "was developed to be a pool of human knowledge, which would allow collaborators in remote sites to share their ideas and all aspects of a common project."

Using the WWW, a music lover in New Zealand, for example, can view a multimedia WWW document or *web site* of a French recording artist. This web site may contain information such as:

- A picture of the recording artist
- A text of the artist's biography
- An audio clip from one of the artist's CDs
- A video clip from one of the artist's live performances

The key to the understanding the power of the WWW is this: the picture could be on the artist's home computer which is physically located in France; the text could be on the artist's manager's computer, which is physically located in the United States; the sound clip could be on the recording label's computer physically located in London; and the video clip may be on the promotional company's computer housed in Germany.

The WWW helps to manage and fuse distributed pieces of information seamlessly into one document or web site. This ability to fuse diverse information from distributed sources, potentially all over the globe, is the key to the power of the WWW. With the WWW, the Internet comes to life for the ordinary person—offering multimedia information at the click of a mouse. Before the WWW, the Internet was keyboard driven. To interact with the Internet, one had to use the keyboard to enter esoteric commands.

In the next chapter, you will learn how to build your own web site on the WWW, so that others can access your information. The reason it is called the World Wide Web should now be apparent. The information (text, graphics, sound, video, etc.) that comprises a WWW document, or web site, can be viewed literally worldwide. In addition, the term *web* comes from the fact that the Internet is interconnected, as shown in Fig. 2.

WHO IS ON THE WWW NOW?

The Internet is becoming a meeting place for artists, engineers, retailers, educators, and many others. The Internet is quickly sweeping into more and more households, and pulling people from every profession into it. Its uses are unlimited for anyone who knows how to tap into its potential. By the year 2003, conservative estimates predict, over one billion people will be on the Internet.

I have collected various demographic statistics and graphs which will help you to assess who is on the Internet today and what are the trends. If you review these graphs, you will notice that the Internet offers an attractive marketplace not only to market and promote yourself, but also to sell products and services directly online.

41 ◄

The current demographics reveal that there are nearly 40 million users on the Internet. Of the 40 million on the Internet, the statistics reveal that nearly 20 million have access to the WWW. Most of those on the Internet are educated and middle to upper income. Women are the fastest growing group. Following are some graphs for your perusal.

In reviewing these graphs, it is apparent that nearly 50 percent of Internet users are in the age group of twenty-five to forty-four. The average income is between $50,000 and $75,000. These users surf the Internet daily. Studies also reveal Internet users watch 25 percent less TV. Based on

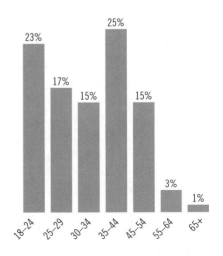

Fig. 3. Age distribution of U.S. Internet users.

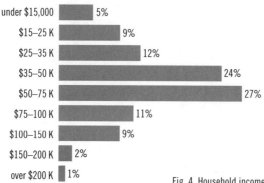

Fig. 4. Household income of U.S. Internet users.

current usage statistics, many experts predict that by the year 2005, more people will use the Internet than watch network TV.

Those on the Internet are educated and have well-defined tastes. They enjoy discussions, have fun exploring, and are willing to spend money on art and entertainment. For artists who want to create an audience for their art and creative works, these demographics are excellent. Furthermore, this group of Internet users will also purchase products online. By the year 2000, over $1 trillion of commerce will be conducted using the Internet, each year.

Coopers and Lybrand, one of the world's most respected management consulting agencies for major corporations, said that "businesses should act now to seize the new opportunity that electronic distribution channels represent. Merchants who consider this as an either/or option are making a big mistake." On the level playing field of the Internet, artists and arts organizations should also heed this advice. Fundamentally, most independent artists and arts organization *are* running businesses. The Internet offers cost-effective and far-reaching promotional and marketing benefits for building those businesses.

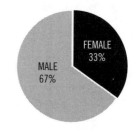

Fig. 5. Gender of U.S. Internet users.

Today, many artists and arts organizations suffer from the inability to reach and to engage their potential audience. From my research in neuroscience, I learned that in human beings, the speech communication

Fig. 6. Job functions of U.S. Internet users.

centers of the brain are juxtaposed with the motor cortex. This means that those who have serious speech communication impairments typically have movement problems or are disabled. Artists today are disabled by their lack of tools to reach and to communicate with their potential audience. Artists with great talent struggle to meet the right agent or the right contact, while their careers remain paralyzed. The Internet is a powerful vehicle for communication that empowers artists and arts organizations to go directly to their audience. It is an instrument of change. Learning how to use this instrument and the various tools it offers, will make you an active participant in the growing communications revolution.

43 ◄

TOOLS for REVOLT

There are various tools which can help you take advantage of the Internet. Among them are electronic mail (e-mail), UseNet newsgroups, mailing lists, File Transfer Protocol (FTP), Archie, Telnet, Internet Relay Chat (IRC), Gopher, WWW browsers, WWW search engines, and WWW directories. By understanding what these tools are and by learning how to use them, you can take advantage of the Internet. Do not be afraid by the technical-sounding terms used to refer to these tools. These tools are software programs for communicating and navigating on the Internet. They are analogous to other tools such as a pager, telephone, car, or bus you may use to communicate and travel in the physical world.

E-MAIL: ELECTRONIC MAIL

All of us have sent letters, postcards, and packages to our friends and family. Electronic mail, or e-mail, is a way of sending electronic messages using the Internet. E-mail has been in use since the beginning of the Internet. With access to the Internet, you can send and receive e-mail to and from any one of the 40 million people who are on the Internet today. In order to use e-mail, you first need an *Internet account* from an

Internet access provider. An Internet access provider is a company that will physically connect you to the Internet from your computer at your home or office via an Internet account. In the chapter "Getting On," you will learn how to get in touch with an Internet access provider and get your own Internet account.

Before you can send and receive e-mail, you need an Internet account. Once you get an Internet account, you will automatically be given an *e-mail address*. The e-mail address is made up of three parts: 1. *an account name*, 2. the "@" symbol, and 3. the domain name of the Internet access provider.

Brant Wojack, a student at the Berklee College of Music, recently got an Internet account. He wanted to use e-mail to reach and communicate with other musicians and industry representatives on the Internet. He needed to first get his e-mail address. Internet access providers have their own domain name. The Internet access provider that Brant used had the domain name of *arts-online.com*. Brant was also given the opportunity to choose his own personal account name. He chose, for obvious reasons, *brant*. Fortunately, no one else had taken the name brant. Thus, his e-mail address became *brant@arts-online.com*. This e-mail address is verbally read, "brant at arts-online dot com." The "@" symbol is used to separate the user account name from the Internet access provider's domain name. Brant immediately placed his e-mail address on all of his stationery, promotional kits, and business cards. It is quite common now to see e-mail addresses alongside phone and fax numbers on business cards. The e-mail address allows anyone on the Internet to contact Brant directly.

The actual sending and receiving of e-mail is done through a software program called an *e-mail reader*. There are many popular e-mail readers on the market. These e-mail reader software programs are available through the Internet access provider. E-mail readers present e-mail in an easy-to-read format and usually allow you to save and search messages. E-mail readers provide convenient ways of responding to e-mail. You can, for instance, read an e-mail and then forward that e-mail to a friend using these programs. I have found this forwarding feature to be particularly useful in passing on valuable information to colleagues. When you forward or send e-mail, you send it to another person's e-mail address.

For those beginning on the Internet, I encourage you to learn how to use e-mail. E-mail is the most widely used tool on the Internet. More people use e-mail than use the WWW. All of the nearly 40 million on the Internet use e-mail. Only 20 million use the WWW. Thus, it is imperative that you learn how to use e-mail to reach the widest possible audience on the Internet. As you use the Internet, you will find that e-mail becomes second nature. You will begin to ask others for e-mail addresses just the way you ask for telephone numbers. Mastering e-mail will prepare you for other activities on the Internet such as using UseNet newsgroups.

USENET NEWSGROUPS

To many users, *UseNet* becomes their sole vehicle for participating on the Internet. Next to e-mail, UseNet is the most widely used feature of the Internet. No special hardware is required to access UseNet, only software. This software, known as a *news reader*, is often made available by the Internet access provider.

The UseNet was originally developed for the exchange of technical information; however, the UseNet soon became more widely popular because of the development of *newsgroups*. Newsgroups were developed for non-technical subjects such as hobbies, social interests, politics, and other news items. Today there are over ten thousand newsgroups from both technical to non-technical topics. If you can think of a topic, it is more than likely that there is already a newsgroup for that topic on UseNet. Newsgroups can get very specific. There is one newsgroup, for example, on audio equipment; and there is another newsgroup for *high-end* audio equipment.

Understanding the usage of newsgroups also requires a better understanding of what the UseNet is. First, the UseNet is not a network, but rather a feature or service offered by the Internet. One way to think of UseNet is as an organized e-mail system, except that there is no single person receiving the e-mail. Messages that you or anyone else using UseNet send, are sent to a newsgroup section. The UseNet is not managed or controlled by anyone specifically, but is subject to a more-communal control. There are no written rules about the kind of language one can use in submitting an *article* to a newsgroup or about one's behavior on UseNet. There are, however, generally accepted community

standards, or *netiquette*, for communicating in newsgroups. In Chapter 9, "Cyberpublicity," the basics of netiquette are covered.

Newsgroups are essentially ongoing conferences devoted to specific topics, which are conducted by public e-mail. The first newsgroup ever created was a newsgroup to convey and discuss the latest news about the Internet itself. In order to participate in a newsgroup, you first have to *subscribe* to the newsgroup. Subscribers to newsgroups participate in newsgroup discussions by *posting* their messages to the newsgroup. The posting of a message makes that message publicly available to everyone accessing that newsgroup. Posting of a message is as simple as sending e-mail to that newsgroup. There are no membership requirements for newsgroups. Anyone who can read a newsgroup's message is free to add comments to a given *message thread*. A message thread is the list of messages and replies that constitute the newsgroup's discussion.

Once inside a newsgroup discussion, you may respond by either replying to the originator of the message privately, or by sending a response to the newsgroup for everybody to read. Because newsgroups are composed of so many people all expressing their opinions, arguments can ensue. When this happens, it is termed *flaming*, and it can often lead to *flame wars*, in which more heated dialogs occur. There is sometimes a fine line between a respectful, reserved argument and flaming.

As mentioned before, there are over ten thousand newsgroups on UseNet today. The UseNet user community has tried to create newsgroups that are tightly focused on a subject. To help differentiate newsgroups, there are conventions which have been developed to name newsgroups. There are various levels of naming that help to specify and categorize a newsgroup. The first level of identification of a newsgroup is a *generic identifier* that lets you know immediately whether the newsgroup is technical, social, recreational, or some other general category. Here is a list of the generic identifiers and their associated categories:

GENERIC IDENTIFIER	CATEGORY
biz	Business
comp	Computers
news	General news items
rec	Recreational (hobbies and arts)

sci	Scientific
soc	Social
talk	Debate-oriented
misc	Newsgroups not in the above categories

In addition to the types of newsgroups listed above, there is also the UseNet "underground." This is a smaller set of newsgroups with the generic identifier "alt" where stronger language and behavior are tolerated. Some have compared these newsgroups to underground newspapers.

Following the generic identifier, there is usually a second level of identification using the *primary subject area identifier.* The primary subject area identifier identifies the general topic of the newsgroup. For example, birds are the primary subject for the newsgroup *rec.birds,* which is dedicated to discussing the fine pleasures of bird watching; biology is the primary subject area for the newsgroup *sci.biology,* which is dedicated to biology-oriented topics; and "tasteless" is the primary subject area for the newsgroup *alt.tasteless,* which is dedicated to discussing weird and bizarre material.

In many cases the newsgroup is divided beyond the primary subject area to a second level. The second level of identification occurs when a newsgroup becomes too broad for the subscribers to gain value from it. For example, the newsgroup *rec.arts.books* and *rec.arts.movies* are dedicated to different aspects of the arts. The newsgroup *rec.arts.books* serves to discuss authors, books, and the publishing industry in general. The newsgroup *rec.arts.movies* is a group to discuss all aspects of movies and movie-making. Finally, newsgroups can have a third level of division, to get even more specific about the topic of discussion.

Once you subscribe to a newsgroup, you will want to post your own comments or messages. UseNet newsgroups were designed to inspire and to support such communications between users in an open forum. I encourage you to join several newsgroups that you find interesting. Learn to use newsgroups. They will be central to your success in promoting yourself on the Internet. The chapter on cyberpublicity will give you more details on how to use newsgroups to reach targeted audiences. The more specific issues of *netiquette* and *signatures* will also be covered in that chapter.

MAILING LISTS

Once you have an e-mail account, you can subscribe to Internet mailing lists. Mailing lists are similar to newsgroups, but they are far less interactive. You put your e-mail address on a mailing list of a particular topic. The items sent to those on a mailing list are more likely to be articles and longer pieces of information, rather than the short comments that typify newsgroups. Also, while one must key in a command or two to read the latest newsgroup messages, the material sent to mailing list members automatically arrives via their e-mail address. In most cases, getting your name added to a mailing list is as simple as sending an e-mail message to a given e-mail address.

You can subscribe to various mailing lists. There are mailings lists on such topics as archaeology, arts, comics, and politics. My friend John R. Howe is currently completing his first book. As a writer, John belongs to various mailing lists for writers. A mailing list for members of the National Writers Union, for example, first alerted John to the potential value of the electronic rights to his book, a biography of an Alaskan naturalist. As John recalls, "I was in the middle of negotiating a contract with a university press, and one of the threads on the mailing list gave me most of the information I needed to talk intelligently with my publisher about this cutting-edge issue." Mailing lists, therefore, can become a practical resource for those in the arts to stay current with issues related to their particular field or art form.

TELNET

Telnet is a basic Internet service which allows you to access remote computers as if they were local to you. To use Telnet, you must have the Internet domain name of the remote computer. The domain name could be *acme.com*. Upon Telnetting to the remote computer, you are presented with a login message. By entering a valid user name and password, you can log into the remote computer as if it were your local machine.

Telnettable sites include libraries, universities, government agencies, and private systems. In libraries, you can call up the card files. In universities, you can look into campus directories and library files, access databases, and see what's new on campus. Most public service sites let you use the login name *guest* or *demo* and any letters for the

password. If this is not successful, the site probably does not want you telnetting in.

FTP: FILE TRANSFER PROTOCOL

FTP, or File Transfer Protocol, is the standard protocol for copying files from computer to computer on the Internet. FTP was one of the first tools developed on the Internet. This tool enables you to connect from your local computer to a remote computer on the Internet. Once you are connected to the remote computer, you can view and browse through list of files on the remote computer. With FTP, you can retrieve, or *download*, a file from the remote computer to your local computer. Similarly, you can place, or *upload*, a file from your local computer to the remote computer. FTP allows files to be transmitted in either ASCII or binary mode. The binary mode should be used on all files that are not plain-text ASCII documents. Graphic images, sound files, video files, and word processing files should all be transferred using binary mode.

Like Telnet, FTP allows you to access remote machines. However, where Telnet allows you access to the power of the remote machine, FTP limits you to sending and receiving files. When you connect to a remote computer using FTP, you will receive a login prompt. Logging in using the login name *anonymous* often allows you to proceed by entering your e-mail address as the password. You are then allowed to see a directory of files that you may download. Recently, I found a site in Chile which had some great free software, or *freeware*. I was able to download the software and have it running on my machine in a few minutes. If I had to write the same piece of software, it would have taken me weeks.

In the above case, I knew exactly the name of the file that I wanted to get from the computer in Chile, and I also knew the domain name of the computer that file was on. This may not always be the case. For example, suppose you are a musician and you want to retrieve a piece of software that allows you to play MIDI audio files on your computer. Before you can use FTP, you need to know the file name of that piece of software and the domain name of the remote computer where that file is located. The Internet tool Archie can help.

ARCHIE

Archie can help in finding the domain name of the remote computer that has the file that you are interested in. Archie was the first information retrieval system developed on the Internet. Archie consists of two components: 1. a central database, and 2. a search program for finding items in that database. The database contains the names of files available on FTP sites throughout the Internet with the associated domain name of the computer containing that file. The Archie search program allows you to type a file name and find the domain name of the remote computer containing that file. To build its database, Archie periodically connects to FTP sites and downloads lists of all the files that are on those sites. These lists of files are merged into a database which can be then be searched.

To use Archie's searching features, you connect to a site that has an Archie database. Once you are connected, you can search the database for a file. Because the database only knows the names of the files, you must know at least part of the file name for which you are looking. For example, if you are the musician looking for the software program that

▶ 52

will play MIDI file, you would search the database for the word *midi*. The Archie program will return the domain names of all remote computers having a file starting with the word *midi*. You can then use FTP to go to one of the remote computers and retrieve the file.

One of the limitations of Archie is that not all sites on the Internet are part of the Archie database. There may be files that fit your specification, but because they are not in the Archie database you may never find them. Despite such limitations, Archie is still a very useful tool for locating files to download through FTP.

GOPHER

Gopher is another tool for distributing information on the Internet. Those sites on the Internet that distribute information using the Gopher system have Gopher servers. Users accessing Gopher servers are provided with a menu-based interface for accessing information. The functionality of Gopher is similar to FTP. Displaying or downloading a file using Gopher, however, is as easy as selecting an item from a menu. This ease-of-use, plus the ability to put descriptive titles on the menu items, makes Gopher a much easier method of browsing files than simply using FTP.

Gopher is a text-based *browser*. A browser is a program that allows users to view lists of files and the contents of files. Browsers also contain features for moving between files with varying levels of ease. Gopher falls short of other browsers such as WWW browsers in that it does not have the ability to integrate images, sound, and video nearly as well as WWW browsers do. However Gopher+ (a Gopher extension run by many sites) does have support for basic WWW pages and can handle some of the formatting commands.

INTERNET RELAY CHAT

Internet Relay Chat, or IRC, is a service that was developed in the late 1980s. IRC enables multiple people to "talk" simultaneously by typing words on the keyboard. Like many other tools on the Internet, IRC is a *client/server* application. People who want to talk with each other must be running the IRC *client* software on their local computer and they must connect to a remote computer which is running the IRC *server* software. Once on the server, they select the *channel* on which they want to talk. Channels are often named for the topic they discuss, if they restrict themselves to a particular topic.

53 ◄

When you are involved in an IRC channel, you can write to the other participants from your terminal while you see what others are writing on theirs. This is an interesting way of having a real-time conference, but speed of communication is rather slow since typing is much slower than speaking. It does, however, allow everyone to participate equally and prevents one person from taking over the conversation by "shouting" or "talking" continuously. IRC differs from UseNet in that messages posted to IRC are displayed instantaneously in real-time.

IRC is composed of groups or channels. Just as UseNet gives access to thousands of newsgroups, thousands of channels on IRC are accessible and organized. Many UseNet newsgroups have corresponding IRC channels. If you have a question, you can simply hop on a related IRC group and ask any of the members of that group the question. Anyone who knows the answer will give it to you immediately, in real time.

An IRC channel is always prefixed by the character #. In the course of IRC's existence, certain channels have earned a reputation. The two that I have found to be quite fun and interesting are #hottub and #hamlet. The #hottub channel started as an attempt to simulate the

atmosphere in a spa-type hot tub. This was one of the first theme channels to be created on IRC. The #hamlet channel gives you a front row seat to the most popular computerized theater. On #hamlet, individuals assume different parts in various Shakespeare plays and perform them at certain times during the day.

Because of IRC's real-time nature, it is extremely addictive. People enjoy spending hours talking back and forth with other people around the world. Many deep friendships are created on IRC channels, and IRC has even spawned many romances (although the lovers rarely meet face-to-face). IRC keeps people's identities private by allowing you to pick a nickname. Some have called IRC the CB-radio of the Internet. Artists, for example, can use IRC with a WWW browser to have real-time discussions about a piece of art, a recent performance, or legal rights issues.

WWW BROWSERS

All of the tools mentioned so far have one major distinction when compared to the WWW and WWW browsers. These tools can all be run without the use of a mouse; they are keyboard-driven tools. The WWW and WWW browsers were designed to be used with a mouse. This is what makes the WWW and WWW browsers distinct.

WWW browsers are software programs that enable you to read and navigate WWW documents or web sites. Using a WWW browser and a mouse, you can literally point and click at elements of the document, called *hyperlinks*, and an action will take place. The action may involve taking you to another page, downloading a sound file, or transporting you half way across the world to another document on another computer. WWW browsers can only be used to navigate and read documents that are encoded in a language called HTML (HyperText Markup Language). HTML allows a single document to contain text, color images, sounds, and movies. Any item, such as a sound file, can be hyperlinked to another document—text, image, or sound. As the user views a document, portions of the document may be selected by the user to cause other related documents or items to be retrieved. HTML documents are always text documents that have special commands in them that indicate pictures, sounds, movies, hyperlinks, and formatting.

There are many WWW browsers on the market today. The first

browser was developed at the National Center for Supercomputing Applications (NCSA) in Urbana-Champaign, Illinois. This browser, called Mosaic, was developed by Marc Andreessen and Eric Bina. Marc Andreessen left NCSA to start Netscape Communications, Inc. Netscape is the developer of perhaps the most famous WWW browser called Netscape *Navigator. Cello*, another browser, is also popular on the WWW. Many other companies are starting to build WWW browsers.

Online services such as America Online, Prodigy, Genie, Compuserve, Microsoft Internet, and Delphi have been forced to develop WWW browsers. Why do I say forced? These online services have their own private "pay-per-view" computer networks, which are not a part of the Internet. For years, these online services have had several millions of customers using their private networks. When the Internet WWW took off in 1994, many of these customers demanded that they be given access to the Internet WWW, or they would leave these private networks and get accounts on the Internet through an Internet access provider. In order to satisfy their customer base, these online services quickly developed WWW browsers to enable their customers to access and to view sites on the WWW.

Unfortunately, the early WWW browsers developed by these online services were slow and lagged behind in technology compared to Netscape's *Navigator*. Many of these online services are now playing catch-up with Netscape in terms of WWW browser development. Microsoft Corporation, whose imperial goal was to develop their own private network, has now taken the approach of getting back into the Internet WWW market by developing and selling its own WWW browser software called *Explorer*.

WWW DIRECTORIES

Internet WWW directories can be used to find web sites on the Internet. WWW directories are like the *Yellow Pages*. They are organized by categories such as Arts, Computers, and Travel. Within each category are sub categories and sub-sub categories. At the deepest level of these directories are listings of web sites on the Internet that correspond to the category or categories. Since everything is mouse driven, a user simply points and clicks to navigate to a web site of interest.

Today there are over three hundred Internet WWW directories. The

oldest and most famous is called Yahoo, which began as a project of two Stanford graduate students. Millions of people visit Yahoo every day and find interesting web sites to explore. Yahoo does not charge for a web site to place a listing in its directory. Yahoo, however, makes money by selling advertising banner space at various locations on its web site to companies such as Honda, Coca Cola, AT&T, and others.

For those of you who have a web site, it is vital that you post your web site address on the right WWW directories to attract the right kind of clients. In the chapter on cyberpublicity, we will go over methods for using WWW directories to market yourself on the Internet.

WWW SEARCH ENGINES

WWW search engines are powerful tools for finding web sites based on user-defined criteria. The criteria for most search engines is a word or a set of words. Different search engines use these words in different ways to locate web sites. There are three major ways in which search engines use these words to locate a desired web site.

The first is to look for the words in the actual text of the document. For example, the search engine Alta Vista, by Digital Equipment Corporation, literally searches millions of WWW documents on the entire Internet and locates all web sites that have the set of words prescribed by the user. If you type in the word *music*, this search engine will display a list of all web sites that have the word *music* in the text of the web site. You can also combine words. For instance, entering "landscape and photography" will return all web sites that have both the words *landscape* and *photography* in the text body of the web site.

The second way search engines use the words to locate a web site is to look for those words in specific parts of the web site, such as the heading or the title. Thus, the person registering a web site with these search engines must make sure that the header or title has the significant words. Otherwise, the web site may be hard to find.

The third way search engines use the words to locate a web site is by comparing the words given by the user to descriptive *keywords* attached to that web site. When a person registers a web site with some search engines, they can associate keywords describing their web site. These keywords may or may not appear in the textual body of the web site. The keywords, therefore, could be more conceptual descriptors of

. .

the web site. For example, a web site for Boston Ballet might have the keywords *theatrical production* associated with it, even though the words *theatrical* and *production* may never appear in the textual body of the web site.

There are many search engines on the Internet WWW. The two earliest search engines were Yahoo and Web Crawler. America Online, seeing the growth of usage of Web Crawler, bought Web Crawler in mid 1995. Yahoo, started by two Stanford graduate students, is now a full-fledged company, backed by major venture capital. These and other search engines do not cost anything to use. Similar to WWW directories, these search engines make money through corporate and business advertising.

The tools presented above are the basic ones you will need to know to make effective use of the Internet. New software tools to navigate, access, and distribute information on the Internet are being written every day. In chapter 15, "Intelligent Agents," some of the latest and most powerful tools in development will be discussed. While these more-sophisticated tools will no doubt revolutionize our activities on the Internet, e-mail and the WWW will still be the mainstays of Internet communication. By learning to use these and the other tools described above, you will create the basis for continuing to level the playing field of the Internet.

LEVEL PLAYING FIELD

In the preceding chapters I have used the phrase "level playing field" to describe the egalitarian features of the Internet. On the level playing field of the Internet, an individual and a major multi-billion dollar corporation stand shoulder to shoulder. Each has the same constraints and the same ease of access to the Internet. For artists, arts organizations, and businesses that have limited budgets for marketing and promotion, this level playing field offers a unique opportunity to give the majors in the industry some serious competition.

In some ways, individuals and small businesses may have a distinct advantage on the Internet. Major companies and advertising agencies are used to *traditional advertising*. They are not used to the features of the *interactive communication* that the Internet offers. Those who can learn the elements of interactive communication on the Internet will have a significant advantage over the established forces of mass media.

TRADITIONAL ADVERTISING

About a year ago, I gave a talk at J. Walter Thompson (JWT), the second largest advertising agency in the world. I discussed the differences between traditional advertising and interactive communication. Among those who attended was the senior vice-president of advertising. After

the talk, the woman who had organized the event said that she had never seen this executive so attentive to a talk in the twenty years she had known him. The senior vice-president said that I was "like Santa Claus who had brought him the whole North Pole." He said I had offered him viewpoints and answers to problems he had no idea how to approach.

JWT, even today, has not made full use of the Internet or the WWW for its multi-billion-dollar clientele. Why not? There are two reasons. One reason is that traditional advertising agencies such as JWT are already making billions of dollars in traditional media such as TV, print, and radio, and they don't see why they should become interactive. The second reason is that they do not have a clue, with all due respect to JWT and other traditional advertising agencies, about how to create interactive communication. Thinking interactive requires effort and the "unlearning" of old ways. Learning new ways requires even more effort.

Traditional advertising is based on the *reduction of information*. Lots of information about a product or service is funneled through a narrow bandwidth of extremely costly TV, print, and radio advertising to create a thirty-second sound bite, a sexy photograph, a jingle, or a saying like "Let go, my Butterfinger." The viewer never really knows the product, but neurons in the viewer's brain have been indelibly stamped with the short sound bite or image.

Traditional advertising is *uni-directional*. The advertiser finds a market for a product or service, creates a message, and splatters that message as far and wide as possible. The receiver of that message can either listen to it or not. There are few other choices. The advertiser is in the driver's seat. The viewer can go for the ride or get off. There is no room for audience response. There is no way to track accurately who heard the message.

Traditional advertising is *costly*. It is for the few and the rich. There are only so many TV stations, radio stations, and major magazines. Getting prime-time access to these traditional means of advertising is cost prohibitive for most artists and arts organizations. When it comes to reaching a global audience, there is no level playing field in the world of traditional advertising.

INTERACTIVE COMMUNICATION

I have used the word *communication* rather than *advertising* in conjunction with *interactive*. Interactive communication is getting closer to real communication. Real communication is not just one person listening and the other person spouting out information, as in traditional advertising. True communication involves the mutual exchange of information and ideas.

Interactive communication is *bi-directional*. In an interactive situation, I am offered the chance to respond and make choices as to what I do or don't want to hear. I can ask questions and explore what interests me. On the Internet, for example, a user can communicate interactively by leaving e-mail messages, filling out forms, and even leaving notes in *guest books* to indicate one's likes and dislikes.

Interactive communication is *personalized*. On the Internet, if I don't like the look of a web page, I can leave. If I like something, I can follow certain hyperlinks and probe deeper. Someone else coming to the same web site may have a very different experience than I, based on what each of us chooses to explore.

61 ◄

Interactive communication *costs pennies* compared to traditional advertising. On the Internet, a web site can be developed and maintained for pennies relative to the cost of developing a traditional marketing campaign. A web site can also be updated as frequently as desired.

In interactive communication *the customer is in control*, not the advertiser. This is a major paradigm shift for the world of traditional advertising. In interactive communication, the deliverer of a message must be a communicator of relevant, appealing, and up-to-date information. If not, the customer will come to a web site and hop to one of a million other sites (or channels) that are available, in a fraction of a second. This feature has made some people call the Internet *clickatron* because at the click of a mouse button, a user could be half way around the world.

Interactive communication is about *infotainment* or *edutainment*. Unlike traditional advertising, which reduces information, the paradigm for interactive communication is to inform and educate. The best web sites make informing and educating the audience fun and entertaining. A web site should be organized for the user to explore information as deeply as they want to go.

EVERYONE IS A PUBLISHER

As mentioned above, interactive communication demands that the provider of the information make it *relevant*, *appealing*, and *current*. If one simply views their presence on the Internet, such as a web site, as a form of advertising in the traditional sense, success on the Internet will be slim. When building an Internet presence, one should view oneself as a *publisher* not an advertiser. This means that one has to provide relevant content, make changes to that content, and find ways to build a circulation (or traffic to the web site). If the content of an Internet web site has not changed for some time, for example, the audience for that site will steadily decline. The model of traditional advertising does not make all of these demands. Imagine if an advertiser had to change their TV ad every week? That advertiser would soon be out of business.

Advances in hardware technology are also further supporting the paradigm of becoming a publisher versus an advertiser. The Internet, and the latest advances in low-cost computer hardware and equipment (scanners, CD-ROM readers and writers, video digitizing boards, and sound boards) are enabling many individuals and small businesses to become literally one-person publishers and "broadcasting" stations. Anyone with the right talent and hardware can become a publisher or create a radio station or TV station producing interactive communications that are current, appealing, and personal. This is what it is meant by a level playing field.

Many journalists who understand this feature of the Internet, and the low-cost desk-top publishing technologies, are concerned. As one journalist commented:

> Talking about journalism in this world is a whole other matter. Part of the reality is that we're funded by advertising, and you don't pay the full cost of all those wonderful stories we send out to you. In fact, you pay about 20 percent of the cost of them and advertisers pay the other 80 percent. But, suddenly, if all of you become broadcasters—and it's very cheap for you to do it—all you need is a personal computer that you can buy for $1,000, a modem, a phone line. What's left for us? And where do we get the funding to have all of our talented journalists out gathering news and delivering it to you? To me, that's the big question. There's an economic question here of how traditional journalism

. .

continues. . . . So, the world is changing in a very rapid and dramatic way. I believe it's going to be good for democracy and good for the country. I'm not sure if it's going to be good for journalism.

Michael Hawley, a professor at the Media Laboratory at MIT, looks forward to the democratization of communication. In a recent interview with the *New York Times*, he said, "In the past, producing information for broadcast media has required so many resources to become a George Lucas, that there can only be a few each century. The Internet is turning that upside down. In the future everyone will be able to contribute their useful bit."

Others, such as John Barlow, lyricist for the Grateful Dead, point out the current problems with broadcasting and traditional media in terms of tracking audience response. Barlow says:

> All of the broadcast-support models are flawed. Support from either advertisers or government has almost invariably tainted the purity of the goods delivered. Besides, direct marketing is gradually killing the advertiser-support model anyway. Broadcast media gave us another payment method for a virtual product: the royalties that broadcasters pay songwriters through such organizations as ASCAP and BMI. But, as a member of ASCAP, I can assure you this is not a model that we should emulate. The monitoring methods are wildly approximate. It doesn't really work. Honest.

63 ◄

Unlike traditional advertising and broadcasting, the Internet enables its users to receive exact numbers, *hit counts*, on the number of people visiting a web site. Broadcast media guesses, at best. The Internet can offer more accurate and reliable statistics for both advertisers and users without guess work. For commerce and business, this capability will have significant impact.

BROADCASTING VS. NARROWCASTING

Many of you have heard the term *broadcasting*. How many have heard the term *narrowcasting*? J.C.R. Licklider coined the term in his 1960 report to the Carnegie Commission on the future of television. It is a term that is being resurrected to describe another feature of the Internet's

leveling of the playing field. Broadcasting refers to the method of reaching as many people as possible using traditional advertising. Narrowcasting refers to the method of making one's communication available to a targeted niche audience. The Internet is to narrowcasting what today's TV is to broadcasting.

I'll give you a simple example. An emerging national poet, Richard Cambridge, recently finished a series of poems that were written during his experiences undergoing nicotine withdrawal. His poems, the *Cigarette Papers*, were used by some medical therapy groups to help in healing others from nicotine withdrawal and breaking addictions. He wanted a way to reach as many of the other medical therapy groups with his poems. In early 1996, he developed a site on the WWW and narrow-casted his WWW address to other addiction and medical therapy groups. Poetry for use by medical therapists? Anyone will admit that is a niche market. Such niche marketing, or narrowcasting, would have been impossible in traditional media. On the Internet, using *cyberpublicity*, such narrowcasting becomes not only possible but also cost-effective.

▶ 64

Thus, the elements of narrowcasting, the features of interactive communication, and the ability for each one of us to become publishers are democratizing communication. There are two factors that will determine the future leveling of the playing field and the continued democratization of communication. One is the price of hardware. Based on recent history, it appears that hardware prices will continue to fall. This can only benefit the consumer. Most artists and arts organizations, who struggle to raise money for their marketing budgets, can make those marketing dollars go a long way if they become participants, creators, and producers, rather than just consumers of information. This is what the Internet and interactive communication are all about. The second factor is accessibility to the Internet. In the next chapter, "Access for All," we will explore what is needed to ensure such access.

ACCESS for ALL

I f the Internet is to be the catalyst for a communications revolution, it is important for everyone to demand access to the Internet or to work creatively within their communities to obtain such access. Access is one of the most critical issues determining the future proliferation of the Internet and the leveling of the playing field for all. Independent artists and arts organizations have much to gain by the ubiquity of access to the Internet.

POTENTIAL BENEFITS

The Internet is not controlled by anyone. Therefore, the success of the Communications Age will be up to us. Consider the potential benefits—some are already available—with ubiquitous access, these benefits would be available to even more people.

With access for all, people could live practically anywhere they wanted without sacrificing opportunities for fulfilling employment by *telecommuting* to their offices via the Internet. This feature raises several environmental issues. Telecommuting would allow artists to service a global clientele from their studios and homes. The best schools, teachers, and courses would be available to all students, regardless of location,

resources, or disability. Artists and writers could share knowledge and techniques with each other. They could *distance learn* and teach diverse groups of students from anywhere in the world.

Art, literature, science, and technology would also be freed from physical spaces. Art would not have to seen only in museums and galleries. Literature would not have to be kept only in libraries, book-stores, and archives. Science would be made available outside of the laboratories and research institutions. Small businesses could get orders electronically from all over the world. Movies, video games, banking, and shopping could all be accessed from the comfort of one's home.

WHAT KIND OF ACCESS?

Access to the Internet can mean many things. Many people have erroneously considered access to mean the physical access to the Internet. I believe there are actually three important aspects of access to the Internet. The first is the physical connection to the Internet via phone lines, cable, optical fiber, etc. The second is the ability to access and find the information one is seeking. The third is friendly, easy-to-use hardware and software user interfaces.

Physical access to the Internet requires three components: a computer, a modem, and an Internet provider. Each of the three components has a price tag. Fortunately, the price of hardware drops every year. Modems and computers have become relatively inexpensive commodities. For under $1500, one can get a decent computer with fast access to the Internet. Local Internet access providers charge between $15 to $20 a month for dialup access to the Internet. However, in this competitive environment, many of these local providers are going out of business. In the United States, I have found NETCOM On-line Communication Services, Inc. to be the best. NETCOM, furthermore, is dedicated to the growth of Internet usage among local communities and schools. NETCOM is also a supporter of the arts and actively lists and promotes artists and arts-related sites on its Internet WWW web site. They provide *nationwide Internet dialup access*. Nationwide Internet dialup access means that one can get on to the Internet with a local phone call from anywhere in United States. Local providers offer only local access, meaning that if you are away from your home base or out of the area code of your home base, you need to make a long distance

call to get on the Internet. Over one thousand people a day are signing up for access to the Internet through NETCOM. I am confident that NET-COM will be in business for a long time. Furthermore, they are laying down transatlantic cable to Britain and Europe. This means that you can get on the Internet in London or France via a local phone call. (For more information, see "Internet Access via NETCOM" in the appendix.)

Physical access to the Internet can also be accelerated through the development of *public access networks.* In several small towns in New Zealand, small businesses, arts organizations, and artists cooperatives have joined together to buy computers and access to the Internet. Other members of the community have begun to build public access networks that are available to anyone in the local community. Public access networks help build the critical mass of users and services that will make interactive communications more valuable. These networks focus uniquely on the needs of local people and communities. They have the potential to grow into a sophisticated, low-cost distribution system for the information and services of individuals, microenterprises, arts, and other public-service organizations.

67 ◄

In the town of Blacksburg, Virginia, a major public-access network has been organized. After nearly two years of operation, Blacksburg's *Electronic Village* is already linking more than a third of the population, and a third of the local shops and businesses, including various arts and crafts stores. The network also provides access to health care information, job referrals, the ability to apply for municipal permits, local mail service, even movie schedules. "What we're recreating is the old village square where people get together with their neighbors," says Andrew M. Cohill, Project Director of the *Electronic Village.* "Everyone else in the country is fixated on the concept of global connectivity. What people here are saying is: 'We don't care. We want to do Blacksburg stuff.'" Larger networks help create so-called "virtual communities" in which people who are separated by long distances can be linked by issues or interests. These virtual communities are valuable, but they can't go far enough to help citizens in the very real community of Denver, Colorado, for example, who are trying to solve the city's homeless problem. Connecting local groups and organizations takes a communications system that provides access to the requisite local information and to the right people. The Denver *Free-Internet* is placing terminals linked to their network in

area homeless shelters. Through these terminals, people can have access to job listings, social service agencies, and other services. Many public-access networks, like the one in New Zealand, take the next step by providing physical access through donated equipment—subsidized public kiosks or terminals. Many non-profit arts organizations, in particular, can benefit from such proactive methods. Arts organizations that are short on funding should work with local businesses to trade advertising space on the arts organization's web site in exchange for funding to access the Internet. This can also help local artists get free or low-cost access to the Internet.

The ability to find information is another important aspect of access. From the beginning of civilization, priests, learned scholars, and archivists have played a role in preserving our history. Information was given special value. It was denied to some members of society and reserved as part of rituals belonging to an elite. Thus, we cannot simply look at the machinery of access without considering the ability to find information as a part of the access problem. If few people can find you on the WWW, or if it is very difficult for you to find relevant information, then regardless of your physical connection to the Internet, this reduces the value of your being there.

Most search engines on the Internet use keyword searching. Keywords are used to describe "information objects" such as text, images, or audio and video files on a web site. People find these objects by using keywords in search engines to locate them. However, my own doctoral research at MIT as well as others in the areas of keyword searching, term frequency, co-occurrence, and other statistical techniques have proven that keyword searching is a passable solution for some disciplines with highly specific vocabularies but nearly useless in all others.

Keyword searching doesn't take into account the different terms for the same concepts. It also doesn't take into account the information in other languages or the different levels of user access to that information. Searches for information by children, for example, will probably be different than searches by adults. Libraries already use different subject access schemes for children's materials. Furthermore, non-textual items, such as software, graphics, sound, and video do not respond at all to keyword searching.

There is no effortless way to create an organization for information.

The best tools for accessing relevant information are a clearly defined classification scheme and a human indexer. A classification or indexing scheme gives the searcher a chance to develop a rational strategy for searching. In the area of music, *Music Guru*, an Internet WWW music project, is organizing a large part of the World Wide Web's music and music-related web sites into a conceptual framework using both conceptual terms and keywords. This project involves the initial work of many expert human indexers knowledgeable in the music field. The resulting conceptual index of *Music Guru* will enable users to find more relevant and conceptually based information. The advanced conceptual indexing of *Music Guru* will be superior to the WWW directories and search engines of Yahoo, Web Crawler, and the like, which rely solely on keywords.

The importance of new organizational tools for finding and accessing information cannot be overstated. It all comes down to the fact that if we can't find the information we need, it doesn't matter if it exists or not. If we don't find it, it isn't information. There are undoubtedly millions of bytes of files on the Internet that are for all practical purposes non-existent.

Thus, it becomes imperative that the new search engines, new search methods, indexing techniques, and the advanced searching tools are a part of the public resource. If not, then there will be no real and equal access to information. Many of those who want to access what you have to offer, whether you are an artist or an arts organization, regardless of their connection to the Internet or their hardware, will be unable to, simply because they do not have the search tools to locate you. Education and training in learning how to use search technology and classification methods will be essential for success in finding the right information. I highly recommend that those of you who are serious about using the Internet as a research tool to take an introductory course in library science or information retrieval. Such education will result in skills which will be highly valued.

Usable and friendly interfaces are the third aspect of access. Many experts today talk about their concerns for the "last mile." The term *last mile* refers to the last mile of wire and/or cable to deliver information into every home. I think we should be concerned about the *last few feet*. We can easily move information from one computer to another, but how

do we get it from the computer to the human being in the proper format? Not all information is suited for electronic use on the current hardware mediums. Think of those small books you like to curl up in bed with. It's not that fun to curl up with a computer, right now.

Even the Library of Congress has announced that they are undertaking a huge project to digitize 5 million items from their collection. Then what? How do they think we are going to make use of those materials. Sitting down to read a novel in front of a 14-inch screen with bad flicker is really no fun. I don't know of anyone who reads novels on their computer screen. Many people simply will not do it. There are high-definition screens and other devices that are being developed, which will make the computer more visually appealing. Such devices need to be made more accessible. Also, using even a mouse and a keyboard is not the most natural way to interact. The ultimate user-friendly way for humans to interact with a computer would be with voice and gestures. The mouse and keyboard are intermediaries of human interaction with the computer.

There are many commercial products on the market today that enable users to use both speech and gestures. In the last decade, major advancements have been made in speech recognition technology. Apple and IBM are already releasing products to households that allow users to give simple voice commands to their computers. NASA's original development of the *data glove* is also reaching the market. The data glove enables users to send inputs to the computer by using hand gestures. The fusion of speech recognition and gestural technology will make human interaction with a computer far more natural and easy.

Thus, user interface design and development will be a key aspect of access. Many of my friends who are artists don't look forward to using their computers. That's primarily because the user interface for computers is not at all natural. On most systems, one needs to know how to type and use the mouse. I believe that artists need to use computers so they can tell us why they are bad. Such feedback from artists can help us design more friendly and creative interfaces. Technophobia keeps many artists away from computers. Friendly and easy-to-use interfaces can change that.

WHY UNIVERSAL ACCESS?

Now that we understand what access means, we can say why universal access is important. In addition to the potential benefits outlined above, ubiquitous access at an affordable cost is a necessary starting point. Not necessarily for ideological or egalitarian reasons, but for very practical ones and for the common good. Unless every individual, organization, and community has access to interactive communications and the opportunities it offers, the new Communications Age will never realize its potential.

Interactive communication is made possible by a myriad of interconnected networks. Ubiquitous access to these networks is essential in establishing the critical mass of users required to realize its value. This was also true of previous communications networks such as railroads, telephones, and interstate highways. As the number of points or people they could reach increased, their value grew exponentially.

The availability of interactive communications can and should be as common, affordable, and essential as the availability of electricity was during the industrial revolution. As David Hughes, a pioneer in public access networks, has pointed out, "There's no reason in technology or economics why 100 percent of the population shouldn't be connected." Today, knowledge and education are the predominant indicators of individual success. As we progress more deeply into the Communications Age, the skills of network usage and information management will become increasingly essential, as using the keyboard and software are today. There are, even now, hundreds of journals and other information sources which are only available online. More importantly, some of the forms in which information can be presented on the networks, using interconnected links and multimedia for example, make these documents nearly irreproducible on paper. Without access to interactive communications, and without education in its use, groups of people will be cut off from this knowledge-rich world and from the ability to succeed in the information economy.

Consider the other side as well: network users may never learn from the wealth of knowledge and experience held by those who lack access. Despite legitimate cautions about creating an information underclass, it is to some degree the wrong way to frame the issue. We already have such divisions in society today. These divisions have less to do with

technological "haves" and "have nots," than with "who can?" The real question is: will we use the potential of interactive communications to close the gaps in knowledge and opportunity, and to cross lines of traditional prejudices and discrimination, or will we widen them?

CROSSING LINES

M any artists are learning to use the
Internet to cross lines of discrimination
and prejudice. Arts organizations are
beginning to provide vehicles for artists to present their works online
and to reach new audiences. Recently, the Cambridge Multicultural Arts
Center (CMAC) in Cambridge, Massachusetts, teamed up with four other
organizations—Millennium Productions, Inc. (Millennium), the Photo-
graphy Collective of Community Change, Inc. (CCI), Very Special Arts
Massachusetts (VSAM), and Information Cybernetics, Inc. (ICI)—to create
the *First International Internet Multi-Media Arts Exhibit on Racism and
Discrimination*. The exhibition was called *Crossing Lines*.

AN ONLINE UNCENSORED EXHIBIT

Crossing Lines is an ongoing, online, uncensored exhibit accessible on
the Internet WWW. The five organizations that collaborated on the
exhibit wanted to offer artists the opportunity to respond to the issues
of racism and discrimination through their art. The exhibit began with
a call for artists around the world to submit work via the Internet. In
addition, through collaboration with local businesses, arrangements were
made for artists to go to various graphics services to have their works

digitized for submission. The collaborative effort of CMAC, Millennium, CCI, ICI, and VSAM was perhaps the first attempt in the world by local arts organizations and supporters to pool together their resources so that artists who had limited access to the Internet and computers could present their views on the topic of racism and discrimination in an online medium.

Each organization brought its own particular strengths and talents to help build the exhibit. CMAC, which has a rich history of offering multicultural arts programming in dance, music, theater, writing, and visual art, created a physical gallery-like space to view the artwork online. Millennium, with its expertise in art and information technology, created the web site and provided use of its high speed T1 communication line. CCI, which has the only repository in the United States of images that deal exclusively with racism, provided outreach to the communities of color. VSAM, an organization supporting artists with disabilities, popularized the goals and the mission of the exhibit to the disabled community. ICI, a developer of advanced core technologies and intelligent agents, provided the actual computers. The resulting exhibition, while initially slow, began to receive all sorts of submissions from both the local and international community of artists.

Artists from all over the world began to submit uncensored digital works of art in either text, audio, video, or graphics format over the Internet to address the issues of racism and discrimination. This exhibit, therefore, served to use the Internet to address the problems of discrimination. Moreover, those viewing looked at the works with less prejudice since the they did not have a face or a voice to associate with the artist. Using the Internet, the viewer could also hyperlink to more details on why the artist created the work and his or her reason for submitting it.

Artists are continuing to submit works to *Crossing Lines*, which has now become both an online gallery and forum. The success of *Crossing Lines* has served to inspire others to organize similar local and collaborative efforts for a global audience.

ARTISTS WITH DISABILITIES

The Internet offers those with disabilities new opportunities for work and communication. By its very nature, the Internet is creating

▶ 74

opportunities for artists with disabilities to reach a worldwide community of artists and prospective clients from the comfort of their own home. There are various organizations that support and assist disabled artists by providing programs, exhibition opportunities, or information. A few are particularly worthy of mention. Very Special Arts (VSA), based in Washington, DC, is a national organization with affiliated state organizations in all fifty states. In addition, VSA has international affiliate organizations in over eighty countries. VSA offers arts programs for children and adults with disabilities. Each state has its own set of programs and offerings to the community of disabled artists. The national office features national Very Special Arts Festivals, which are a result of on-going workshops, training programs, and special projects. Resources for Artists With Disabilities, Inc., based in New York, promotes public awareness of, and exhibition opportunities for, professional visual artists who are physically challenged. This organization also maintains a slide library available for viewing by exhibition directors and curators.

The Independent Arts Gallery (IAG), based in Jamaica, New York, is a project of the Queens Independent Living Center, a community-based, non-residential center, providing services and advocacy for all people with disabilities. IAG is committed to uniting artists with and without disabilities to build a strong and diverse artistic community. IAG also hosts an annual juried exhibition at Cork Gallery in Lincoln Center. The Disabled Artists' Network, also in New York, publishes a newsletter with information for artists with disabilities.

Of the above organizations, Very Special Arts Massachusetts (VSAM), led by its Executive Director, Maida Abrams, was the first organization for disabled artists to take advantage of the Internet. Ms. Abrams' vision of a web site for artists with disabilities led to the development of VSAM's pioneering web site. This web site not only offers artists with disabilities detailed information on various resources, but also offers art lovers with disabilities access to one of the world's finest directories, *Access Expressed!* The *Access Expressed!* directory, part of VSAM's web site, offers detailed information on hundreds of venues such as theaters, museums, galleries, art centers, and performance centers. New efforts are underway to create a searchable database version of the directory on the Internet. Maida Abrams and the VSAM staff should be applauded by the international arts community for their work in not only compiling such information, but

also having the foresight to use the WWW for making it accessible.

One year after the creation of VSAM's web site, the national office of VSA, in Washington, DC, decided to build the VSA national office's web site and to sponsor the installation of web sites for all fifty state organizations. Today, the VSA national office uses its web site to provide both general and detailed information to disabled artists around the world. They also use their web site for inter- and intra-office communications. In addition, an online gallery at their web site features artists of the month, their works, and the opportunity to buy artwork online. In summary, VSA has taken full advantage of the Internet to promote disabled artists and continues to explore other creative uses of the WWW. VSA also provides training seminars for disabled artists interested in getting online and using the Internet to market their work.

Similarly, the *In Your Face* exhibition by disabled artists in Sydney, Australia, is a new concept that will illustrate an approach not available in most cultural venues. The exhibition will focus on accessibility for people with disabilities. A number of artists with and without disabilities will develop work on the theme of the face and its senses. In addition to physical exhibition space, the *In Your Face* exhibition will use the Internet as a creative/cultural accessible exhibition space. The performance *Into the Light*, another event organized by these artists, was performed during the 1995 World Assembly of Disabled Peoples' International Conference at the Museum of Contemporary Art (MCA) in Sydney. Dancers, actors, and musicians were featured including *Paradox Dance*, a group of international dancers, choreographers, and disabled activists; *Secret Combination*, a group creating a series of dance/movement pieces; and *The Artscope Dance Quintet;* and *Misleading Impressions. Into the Light* became a pilot for future initiatives and a means to highlight ways in which people with disabilities can bring a new focus to dance. In the spring of 1997, Dance Umbrella and VSAM will organize the *First International Wheelchair Dance Festival.* The festival will be featured via live video on both VSAM and Dance Umbrella's WWW sites.

WOMEN ARTISTS

A friend of mine, a woman and an artist, recently asked me to name all the female visual artists I knew. I was only able to think of one, Georgia O'Keefe. My friend's question was a good one. Women are under-

. .

represented in the visual arts. Fortunately, women are the fastest growing group on the Internet. Today, over 30 percent of Internet users are women. Moreover, there are many sites on the WWW where women artists have organized.

One noteworthy site is *The World's Women Online!* An electronic art networking project, this web site began during the organization of the 1995 United Nations World Conference on Women. It has since become an active and current site dedicated to featuring women artists. Utilizing the Internet as a global exhibition format, *The World's Women Online!* site focuses on the challenge of bringing the vast resource of women's experience and culture into the rapidly developing field of information technology.

During the 1995 conference, along with the Internet sites around the world, two key centers for public display and communication were made available on electronic media walls. One electronic media wall was located in Beijing, and the other was located at the National Museum of Women in the Arts in Washington, DC. A video entitled *The World's Women Online!* was programmed into both media walls. Internet transmissions of imagery and text by women artists were also received and mixed with the video on the wall.

77 ◀

There are a good number of new web sites dedicated solely to women artists. There are so many talented women artists, and the Internet will enable them to reach new audiences. Next time someone asks me to name female visual artists, I will be able to name a dozen.

ARTISTS OF COLOR

A few months ago, I saw a television interview with Tony Brown, an African-American journalist and cyberspace enthusiast. Brown told a story of a poor African-American family with a seven-year-old son. The boy had a speech impediment and was one grade behind his class. His parents saved their money and bought their son a computer. The son taught his parents how to use the computer and how to cruise the Internet. One year later, he lost his speech impediment and was also enrolled in the right grade for his age.

The computer and the Internet undoubtedly played a role in the boy's advancement. In 1988, an Educational Testing Service (ETS) survey indicated that home and school access to microcomputers provides a

significant educational advantage to children. Their survey also indicated that these advantages are unequally distributed across economic, ethnic, and gender categories. The ETS, for example, found that 37 percent of children in families with incomes of more than $50,000 have computers in their homes. Only 3.4 percent of children in households with income less than $10,000 have computers at home. The survey reported that 17 percent of all white children, 6 percent of blacks, and less than 5 percent of Hispanics use a computer at home. The survey also found that black children tend to use computers at home much more than their white counterparts. White children used home computers on average 2.8 days/week, black children averaged 3.8 days/week.

For minority artists who have had limited access to an audience, the Internet is a veritable godsend. There are now hundreds of Internet sites promoting artists of color. There are also embryonic developments in providing physical hardware and Internet connection access to communities of color.

Twenty-four strands of optical fiber, for example, were recently laid through Harlem, where basic telephone service is barely 70 percent, 40 percent of the residents live below the poverty line, and nearly 50 percent are out of the labor force. The fiber was laid according to terms dictated in a recent cable franchise negotiation. The New York City Department of Telecommunications and Energy is exploring potential applications for interactive video conferencing between community rooms in city housing projects and city government offices, schools, colleges, cultural institutions, and business centers.

For African-American artists, sites such as AfriNET on the WWW are creating a growing gallery of artists. AfriNET's mission is to provide visitors with the finest and most comprehensive collection of African-American, Caribbean, and African art available. At its web site, there is original art, graphics (traditional printmaking techniques such as serigraphy, lithography, and etching), fine art prints, posters, sculpture, and mixed media. The artists come from all parts of the world, but hold in common their African ancestry. From this common heritage, these artists portray a variety of visual directions, making African-American art one of the most exciting to view today.

The AfriNET also groups the artists into three distinct categories, allowing you to tailor your journey. You may search by ARTIST, by TITLE,

or by STUDIO, using the Gallery Search Form. The search can be changed at any time during the visit. They also feature an Artist of the Month, who is selected from viewer comments. The Artist of the Month feature includes a short biography and examples of current works or those selected from their archives. Their newsletter, *Collage*, as its name suggests, is a collection of information about the artworks. It includes information on different techniques, how to build an art collection, who's who in the arts, framing with style, and more.

The Internet offers great possibilities for uncensored artistic expression. As it grows, more artists, who are currently disenfranchised by the current methods of access to a global marketplace, will find opportunities for making their voices heard. Getting connected to the Internet, therefore, is vital to artistic expression.

79 ◀

CONNECTION

GETTING ON

T here is a big difference
between *getting on* the In-
ternet and *being on* the
Internet. Getting on the Internet is the process of getting physical access
to the Internet by using computer hardware and an Internet access
provider. Being on the Internet means building your own storefront or
web site on the WWW. The next chapter discusses the elements of being
on the Internet.

If this distinction is not clear, some analogies may help. Getting on
the Internet is similar to buying a TV and watching programs. Being on
the Internet is similar to building your own TV station and putting on
your own programs. Getting on the Internet will allow you to access
information on the Internet using the various tools described above. For
example, getting on offers you access to 40 million people via e-mail.
Getting on lets you "tune in" and interact with the thousands of WWW
web sites. Getting on lets you participate in chat sessions, order books
and CDs online, send messages to the White House, and participate in
news surveys.

WHAT HARDWARE DO I NEED?

The first step to getting on the Internet is to make sure you have the right hardware. To get on, you can use just about any old machine. Even extremely slow machines with 300 baud modems allow access to the Internet. However, to use the WWW and to run WWW browsers, you will need more than an old machine and a 300 baud modem. There are five basic pieces of equipment you will need to get on the Internet and to use the WWW. They are:

- Computer
- Keyboard
- Monitor
- Mouse
- Modem

In terms of the computer, you can use an IBM/PC-compatible, an Apple Macintosh, or a larger workstation such as a SUN machine. If you are using an IBM/PC-compatible, you will require at least Windows 3.1 running in 32-bit extended mode. You will need a hard disk that leaves at least 20M (preferably 60M) free, 4 to 8M RAM (preferably 8 to 32M), and a CPU speed of 33mhz 486 (preferably 100mhz 486). If you are using an Apple, you will want one of the faster Macintoshes or Power PCs. For workstations, both SUN and Silicon Graphics offer inexpensive and powerful machines.

Keyboards for all computers are standard. Get a keyboard that you like and that feels good. If you are planning on using your computer often, get a wrist pad along with the keyboard. Wrist pads can help prevent certain injuries caused by strain and overuse.

A good monitor is also extremely important. Since you will be spending a lot of time looking at it, make sure that it is color. A good monitor will produce a black that is very black, with no hints of gray, and a white that is solid, even, and very white. Get a *VGA-compatible* monitor or a *Super VGA*, which is even better. VGA stands for *Video Graphic Array*. Images on the WWW are either in GIF format or JPEG format. GIF images are limited to 256 colors. JPEG images may have up to 16.2 million colors. VGA can handle up to 256 colors. Super VGA can handle all 16.2 million colors for a stunning display of graphics, JPEG images, or movies.

You will also need a pointing device such as a mouse. A mouse is critical to using the WWW. Go to a store and try the different mice. A good mouse can be bought for approximately $20. More expensive ergonomic mice are also available. Pick a mouse which you feel comfortable with.

Finally, you will need a modem. *Modem* stands for modulator-demodulator. You will need at least a 14.4K modem. A 28.8K modem, however, is becoming the standard. Make sure that your Internet access provider can support 28.8K. You can also get an ISDN modem. ISDN stands for *Integrated Services Digital Network*. These modems can be purchased for a little more than a regular modem but require ISDN phone lines. ISDN phone lines are now available in many large cities. The line charge rates vary, but seem to average approximately $30 per month. ISDN gives you multiple 56K lines and enables you to transfer data and voice simultaneously. Of course provider fees are higher for ISDN connection as well. Whatever modem you get, it should be *Hayes-compatible*. Hayes is the company that pioneered much of modern commercial modem technology. Nearly every modem conforms to Hayes standard.

85 ◄

HOW DO I GET THE HARDWARE?

Before you lay out your money, you need to shop around for hardware. There are many choices. There are computer stores in the smallest communities. Large cities have computer superstores with warehouse-type layouts and huge savings. Magazines, as well, offer an abundance of computer ads. The question, then, is do you buy from a store or from a magazine via mail order?

Magazines such as *Computer Shopper* offer the primary advantage of both choice and price. Even computer superstores cannot compete with the sheer number of mail-order companies in a single magazine. Mail-order companies can keep their prices low because they do not need a well-staffed storefront. Magazines also offer the latest technology. Because computer stores tend to enter agreements with certain manufacturers, they are tied to the release schedules of those companies. Magazines have no such limits, and new companies with new technologies appear in every issue.

The primary advantage of computer stores is that they are useful in emergencies. A computer store is essential when you do not have time

to wait for shipment, even if it is the next day. Superstores also often offer prices that are close to the prices in magazine ads. If you are a smart superstore shopper, you can walk away with a purchase that closely matches the magazine's price, especially when considering shipping charges.

The final advantage of a store over a magazine is the security of knowing what you are buying and where you are buying it. With a magazine, you go on faith. I recommend combining the best of both worlds. Buy from a magazine as much as possible, since savings and choice outweigh the pros of buying locally. You may want to go to a local store to get an idea of price and features. You can use the store to play around with different systems and to get an idea of what works for you. Then, turn to the magazine ads to make the purchase.

Another interesting way to purchase is online. Most of the major computer manufacturers now allow you to order computers directly from their web site. This type of online ordering is similar to ordering from a magazine.

When buying computers, another important question is: is it better to buy from a large company? The answer depends on whether you are buying the computer itself or some kind of peripheral device. If you are buying the computer itself, realize that the basic computer system is made up of components that are only made by only a small number of manufacturers. While there are differences between reliability, durability, design, and speed, all the components, regardless of manufacturer, should work well. This extends to PCs manufactured by famous names such as IBM and Compaq. Although Apple is the only manufacturer of its computers (unlike IBM PC clones), most of the important components are not made by Apple.

The fact that there are only a few manufacturers for each of the major components in a computer means that the prices for these components can be kept low. Price gouging is relatively unknown to component manufacturers. The quality of the equipment from the big old companies probably won't be any better than the small new ones. Big companies tend to produce lots of machines at once. Many times flawed designs must be lived with until current stocks have been sold. Smaller companies, with smaller runs, can afford to make functional and ergonomic changes more quickly.

. .

I have used both big-name systems and no-name systems. Except for rare instances, there are no differences in overall quality between machines purchased from big companies and small companies. The main difference, regardless of whether the computer was purchased from big or small company, is how the individual components of the computer were put together. Most computer problems arise from the pieces not being put together correctly. Thus, the most important thing to remember when purchasing a machine from either a big or small company is to make sure the company offers a good return policy and a good warranty.

If you are buying a computer, it is not necessarily better to buy from a big-name company than from a small company; however, if you are buying peripherals (or components), you should always buy from a big-name company. To choose the correct company, read product comparison reviews in popular computer magazines such as *Byte* and *Computer Shopper*. Components could be parts such as a disk drive, power supply, or memory chips.

WHAT SOFTWARE DO I NEED?

Getting the right software is important. There are various pieces of software needed to get connected to the Internet. I urge you to get all of the necessary software at one time rather than in a piecemeal fashion. Getting the all software at once will save you a lot of time. Those people who get the software piecemeal, often spend a lot of unnecessary time installing it and resolving various cross-integration issues.

To get on the Internet, and to use the various Internet tools, you will need the following software:

- **FTP** File Transfer Protocol is a program that lets you transfer files from remote computers. This is the primary way to send and receive data when not using the WWW.
- **Telnet** This program allows you to log onto to a remote computer as if it were attached to your computer. This is necessary to access your remote accounts on your provider's machine.
- **Archie** An Archie program finds files on the Internet that fit a search word you provide. Once you locate a file, use FTP to get it.
- **NetNews** NetNews is a news reader that allows you to peruse any of the thousands of special interest newsgroups on the Internet.

- **E-Mail** An e-mail reader allows you to receive and send personal electronic mail to anyone on the Internet.
- **SLIP/PPP** Serial Line Interface Protocol or Point-to-Point Protocol program is needed for your computer at home to talk to the Internet. This program takes care of communicating between your modem and the Internet.
- **WWW Browser** A browser such as Netscape helps you view information on the Internet in a graphical user interface (GUI) environment using a mouse.

Sounds like an awful lot of software? It would be if you had to get it individually. Fortunately, most Internet access providers will give you all the software when you sign up. In the appendix of this book, you will find a brief description of *NetCruiser*, the integrated software package from NETCOM, which offers all of the above tools on one computer disk. The appendix offers information on how to get *NetCruiser* from one of NETCOM's authorized resellers by mail-order or by calling an 800 number.

▶ 88

THE INTERNET ACCESS PROVIDER

After you have the hardware and the right software, the last thing needed for getting on is an Internet access provider. Today, there are thousands of local providers. Six months ago, I recommended using local providers closest to where you live. However, I no longer believe that many of those local providers will be able to stay in business. Furthermore, many of them provide poor customer service.

Today, I recommend NETCOM and their proprietary software *NetCruiser*, which, as previously mentioned, provides all of the software mentioned above. More importantly, the software is a breeze to install, setup, and use to connect to the Internet. Once you are connected, you can use the Netscape browser *Explorer* to view the WWW.

Furthermore, NETCOM is a national provider, meaning that you can get on the Internet through a local phone call from anywhere in the United States.

BEING ON

Being on the Internet is different than *getting* on the Internet. Getting on involves the hardware, software, and an Internet access provider necessary to get physical access to the Internet. Being on does not require that you even own a computer or have access to the Internet. *Being on* means having a WWW web site on the Internet.

YOU DO NOT NEED A COMPUTER

Being on the Internet does not require a computer. This is important to understand. *You do not need to own a computer, or have Internet access, in order to start taking advantage of the Internet WWW.* You do not need to own a car to have a billboard advertisement on Interstate Route 80. You do not need to own a TV in order develop a TV commercial. Having a TV, however, would give you a better idea of how your commercial looks and how to develop your commercial more effectively. Likewise, having a computer with an Internet connection would enable you to understand the medium better; however, it is not critical to the success of your being on the Internet.

WHAT IS A WEB SITE?

For starters, consider a web site as the digital version of your current print brochures or materials. In these materials, you use graphics, text, and design elements to best represent yourself or your company. A web site contains that same information, digitized and laid out in a format for viewing on a computer screen. That information is accessible to anyone with a web site address on the Internet. A web site address, commonly referred to as the *Universal Resource Locator* (URL), serves to let anyone find you on the Internet. A user can visit your site on the WWW by simply typing the URL address into any standard WWW browser.

A URL address has three basic components: a service, a domain name with optional port, and a path with an optional file name. The first component, the service, tells the WWW browser how to retrieve the file. The service may be one of the following:

- file://
- http://
- gopher://
- telnet://
- news:

The second component of the URL is the name of the machine, or domain name, such as *iseei.com*. The third component of the URL is the path name and file name of the item you want to retrieve. The third component, if missing, will force the WWW browser to load a default file. Some examples of legitimate URLs include: *http://www.arts-online.com/*, *http://www.arts-online.com/allworth/home.html*, and *http://www.cbs.com*. At *http://www.arts-or line.com*, you will find an online multi-arts cybervenue for artists and arts organizations such as Boston Ballet, Alvin Ailey, and Very Special Arts. At *http://www.arts-online.com/allworth/home.html*, you will find the web site of my publisher Allworth Press. Allworth's web site contains reviews of over forty books for visual and performing artists and writers, along with legal advice. The web site at the URL *http://www.cbs.com* is owned and operated by CBS and offers a variety of information including David Letterman's Top Ten List.

A web site is obviously more powerful than a printed brochure. Unlike a brochure, a web site is *interactive*. Not only can users view your

material, they can also order a product immediately, request additional information, post their comments about your material or products, sign an electronic guest book, or let you know that they stopped by your web site using e-mail. A web site brings your information directly to your audience and brings your audience directly to you. The cost of "printing" a web site compared to a regular print brochure is one reason why new web sites are appearing on the Internet every twenty minutes. The cost alone is a feature that can save you thousands of dollars a year.

WHY CREATE A WEB SITE?

There are many reasons to create a web site. It can:

- Generate valuable new leads and mailing lists of prospective clients
- Create awareness of your products and services
- Provide detailed pre-sales information on you and your organization
- Increase your profits by attracting new customers from the Internet WWW's 20 million young, educated professionals with a household income of more than $50,000
- Create new sales channels you won't find anywhere else
- Distribute your products and services faster and more flexibly
- Position yourself and your organization strategically for the twenty-first century
- Improve customer service
- Enable you to update your information instantaneously
- Collect prospective client demographics
- Cut overhead costs
- Find new partners and allies around the world

CREATING A PROFESSIONAL WEB SITE

There are two main phases of being on the Internet. The first phase involves creating a professionally designed web site, one that is both artistically pleasing and technologically sound. Although it may seem obvious, this first phase is often neglected by many organizations. Many organizations simply take their printed brochures and "place" them on a web site. Using interns or "technical" experts, such as a local computer whiz, can make some web sites look amateurish. Most web sites are

simply text with a smattering of bad clip-art graphics. Even multi-million dollar companies have web sites that look like a grade-school student put them together.

Because of the increasing traffic on the Internet, many people are starting to realize that they need a professionally created web site. A successful web site should look as professional as a thirty-second TV or radio commercial. It should contain the proper design elements and represent the image you have worked years to build. There are potentially 20 million people on the Internet WWW who will see your web site. You should make sure they see the best image possible. There are ways to cut corners to reduce your budget, but do not skimp here.

Web page design is becoming a real profession. There are many who have are claiming to be web page designers because they learned HTML and some software graphics program only a few months ago. You do not want someone using your company to experiment with. When you are looking for a professional web page designer, make sure that company or the individual satisfies the following basic criteria:

- Basic knowledge about the Internet
- Professionally trained or equivalent experience in graphic design or other related design field
- Has been in business for at least one year
- Has an existing portfolio of clients
- Has professional training or knowledge in marketing and how to merge traditional marketing with interactive marketing

By all means do not select an amateur to do your web site. It will cost you if you do. You may not realize your mistake right away, but you will at some time in the near future. You are better off spending the time and money to have a professional create your web site.

The other major ingredient of a successful web site is *useful* technology. Once your web site is up, how are you going to receive feedback? How will you communicate with the Internet community? If you have a computer and Internet connection, there are a variety of ways. If you do not, there are certain services available for you to stay in touch with your customers.

With new technologies, web sites can have automatically changing content and other advanced features. It is these features and services that

can make your web site truly interactive, so that it stands out among the thousands of sites already on the Internet. As more sites come on-board, you will want to distinguish yourself from your competition.

THE ANATOMY OF A WEB SITE

There are several important characteristics of a successful web site:
- Professional design
- Fast display of graphics and text
- Ease of navigation
- Easy ways of communicating with you and ordering information
- Frequent updates or content changes
- An area for people to tell you their likes and dislikes
- The element of fun (people want to enjoy their visit)
- Marketing enticements such as coupons, online giveaways, etc.
- Links to other interesting sites

If you plan on taking your web site seriously for the long-term, integrate as many of the above elements in your design as possible. A thoughtful and calculated approach will yield a web site that will earn you positive feedback and comments from your site's visitors.

93 ◀

FINDING A HOME FOR YOUR WEB SITE

Once you have successfully developed a professional web site, the next step is finding a *home* for your web site. If you have a great looking web site that is going to draw people in by the thousands, and one which is going to generate thousands of new leads, new opportunities, and increase your business, the last thing you want to do is place that site on an Internet *server*, or *home*, that is going to be so slow that potential clients are going to turn elsewhere. Finding the right home is as critical to your success as the design.

Finding a home for your web site means finding a company that has dedicated machines and an Internet connection which will allow your web site to be seen. You have to shop to find the best rates for placing this information online.

There are several factors to consider when thinking about where to place your web site. The most important ones to consider are:
- What type of machine is the server, and how powerful is it?

- What type of connection to the Internet does the server have and how many people use that connection?
- How many people can get to your material?
- What is the *focus or theme* of the server? Who does it cater to?
- How does the server or site promote itself, and how will people find this server among the thousands on the Internet?
- How good is the customer service should you have a problem with your site?

The technology today is so new that most people do not consider these questions. They do not know what a "server" is, let alone which is the right one for their web site. Most of the new web sites popping up are the result of companies and organizations rushing to put something online without considering all the factors. Many do not have a clear goal for what their web site is trying to accomplish. Most companies and organizations do not think past the creation of a web site. This will not work.

What type of machine is the server, and how powerful is it?

The first question to be answered is what type of server a company is running. A server is simply a very powerful computer that is connected to the Internet. The reason it needs to be powerful is that thousands of people are connecting to it daily, retrieving information, and asking the computer to perform certain tasks. Without a powerful computer, people trying to look at your information have to wait for long periods of time, which means lost customers.

What type of connection to the Internet does the server have and how many people use that connection?

The question can be rephrased as: how is the server connected to the Internet? This is a fundamental question that could have a great impact on your site. The type of Internet connection to the home (or server) where your web site resides, is a major factor in determining how many people can visit your site.

Consider a public relations company that has phone lines coming in, and a finite supply of operators to answer those phones. Obviously, the more phone lines coming into the company, and operators working at

the company, the more customers a company can handle without giving a customer a busy signal. Assume that number of phone lines coming into the company is the "Internet connection" and that the number of operators answering those calls is the "server."

Now consider, that you, as an artist, went to a public relations company to take care of all your phone calls, so you could get on with the business of creating art. What would be the most important demand that you would make on this public relations company? To make sure that any prospective clients don't receive a busy signal. You cannot afford missed opportunities. You would want the company that had the most phone lines to answer calls and the most efficient operators to process your those calls.

When considering a company to place your promotional information online, via your web site, you want a company that has a dedicated T1 Internet connection. This T1 Internet connection is like having over one hundred phone lines. In addition, you want a company that has a server (analogous to operators) that is fast and efficient at answering requests.

How many people can use the lines? Internet access providers are in 95 ◄ the business of selling you *a* phone line to the Internet. In other words, they have hundreds of phone lines to the Internet, and they will sell you the right to use one of those phone lines to access the Internet. The rub here is that the one phone line they sell to you is not exclusively yours. Up to ten others can share "your" phone line.

Most Internet access providers have thousands of people tying up phone lines getting out to the Internet, while others, including your prospective clients, are trying to get to the information you may have placed on their server. This means that even though an Internet access provider may have a T1 connection, your potential customers may still experience delays *getting into* your web site because they are competing with people who are using the same lines to *getting out* on the Internet. As a result, many people have moved their web sites away from the generic servers of Internet access providers.

How many people can get to my material?

The number of people who can get to your site depends on many factors. The two most important are the type of server and the type of Internet connection. Picking the right company with the right Internet

connection and server will determine the amount of users who can access your site.

The other factor is the type of information they are retrieving from the server. If everyone visiting the server is downloading large amounts of text, graphics, audio, or video, there will be a bottleneck in accessing the server and your web site.

What is the focus or theme of the server? Who does it cater to?

The next question is one that few people have considered, because the Internet is so new, but one which should be a fundamental concern to you. Internet access providers are not in the business of providing a new market for you or your company. Internet access providers do not cater to any individual or organization. Internet access providers make money by selling Internet access. If you wanted to get on the Internet yourself with your computer and "surf" the Internet, you would call on them. Remember, getting on the Internet and being on the Internet are two totally different problems. Many assume that once they get on the Internet using an Internet access provider, that they should also put their web site on that Internet access provider's server. This can be a big mistake.

Again, an analogy is in order to clarify what is happening on the Internet. Imagine a magazine that has no focus and prints whatever a company or individual pays them to print. The same holds true for Internet access providers. You find software companies, automotive companies, artists, labels, airlines, all on the same server.

When thinking about placing your print advertisement in a magazine, your first step should be to identify a magazine that reaches your target market. If you are a record label, you wouldn't place your ad in a travel magazine. You would find a magazine that targets your audience. This analogy holds true for placing your web site.

How does the server or site promote itself or how will people find this server over the thousands on the Internet?

The server that you place your web site on can be fundamental to the success of your web site. Using the magazine analogy, you now want to ask, "How does this magazine promote itself?" Or, in this case, "How

does the server promote its URL address?" A site that caters to your target market is extremely important.

The server needs to be promoted constantly through traditional media as well as on the Internet. The more a server advertises itself directly, the more people will come to that server (and to your site). It's just common sense. But the astonishing fact is that there are few Internet access providers who advertise the URL address of their server in traditional media. Again, Internet access providers do not target a particular audience to their server. They provide space on their server and leave advertising in your hands.

The web site activities of Young Concert Artists (YCA) of New York are an example of the principles discussed above. In mid-1995, YCA working with Millennium Productions, Inc. developed a great looking web site. However, their web site's home was a server in Hong Kong which was slow and did not directly relate to the arts. As a result, Young Concert Artists moved their residence from the server in Hong Kong to a more niche-oriented, arts-specific server with the domain name *arts-online.com*. The new home at *arts-online.com* had four important characteristics: it was connected to a dedicated T1 line; it was for arts specific clients; the domain name of the server was advertised and promoted in over thirty major arts magazines and journals worldwide; and the server was powered by one of the fastest computers on the market.

Young Concert Artists decision to change their residence had immediate results. As YCA pointed out:

> We already had a great looking web site, but hardly anyone was able to find it. Furthermore, when people came to our web site, the site came up really slowly. The *arts-online.com* server, on a high speed T1 line, displayed our web site ten times faster. We have been getting fifteen to twenty unique visitors at our web site every day since our change of residence. Furthermore, we get glowing compliments from our visitors on our design, as well as speed of access.

Moreover, YCA's web design, combined with the speed of access, encourages visitors to make frequent stops to their site.

Being on the Internet, therefore, requires a clear understanding of the principles outlined above. Before you decide to be on the Internet, plan out your strategy carefully and make sure that you have covered all the important areas. A successful WWW presence on the Internet will position you for the next step—cyberpublicity and the marketing of your web site to potential visitors.

CYBERPUBLICITY

web site is only as good as the number and kind of people that come to it. If you have spent a great deal of time getting on to the Internet and building your web site, you cannot afford to ignore the importance of *cyberpublicity*. Cyberpublicity is the art and science of promoting your presence in cyberspace and getting the kind of exposure you need. Cyberpublicity will also serve to give you statistics on the number of people who visit your site, and will allow you to gain useful demographic information on the people visiting your web site.

A web site is only as good as the number and kind of people that come to it. If you have spent a great deal of time getting on to the Internet and building your web site, you cannot afford to ignore the importance of *cyberpublicity*. Cyberpublicity is the art and science of promoting your presence in cyberspace and getting the kind of exposure you need. Cyberpublicity will also serve to give you statistics on the number of people who visit your site, and will allow you to gain useful demographic information on the people visiting your web site.

WHO AM I?

The first step in cyberpublicity is to determine *who you are*. You should take some time to think about it. I normally recommend that clients take some paper and pen, or word processor and keyboard, and jot down the words or phrases that describe them. Most artists know who they are, but they have never tried to categorize themselves using words and concepts. The end product of this exercise should be: one paragraph, at most fifty words, describing who you are; up to twenty keywords that characterize your organization; and up to ten words that describe the broad categories that are related to your organization.

Recently, I helped to cyberpublicize an independent record label. They wrote a fifty-word statement describing who they were. The paragraph briefly described the mission of the label and the kinds of artists they serviced. Next, they gave me twenty keywords. These twenty words included: *new age, music, soft, easy listening, contemporary, New York, haunting, award-winning, Celtic, musician, guitar, flute, vocal, piano, sitar, Indian, bamboo* and *Grammy.* These keywords reflected the traits of their organization. Finally, they gave me a list of ten words describing the categories that their organization could be indexed under: *Weddings, Concerts, Labels, Distributors, Retailer, Music, Awards, Entertainment, Celtic, Indian.*

The above information is central to starting a cyberpublicity campaign. Take time to get the keywords and categories right before proceeding.

NETIQUETTE

Once you have taken the time to figure out who you are, you are ready to start your cyberpublicity campaign. But before taking any direct action, you need to understand the nature of your medium and what the rules of the game are. As mentioned earlier, users of the Internet, including the WWW and UseNet, are expected to follow a set of guidelines for their behavior called *netiquette*. The complete guide to netiquette is available through a newsgroup called *news.announce. newusers.* This newsgroup has articles on the latest guidelines. Before you begin to communicate your information using e-mail, newsgroups, or the WWW, I encourage you to read the articles at that newsgroup thoroughly.

One important rule of netiquette is that insulting, degrading, or racist comments are intolerable, unless you are in one of the underground "alt" newsgroups. It is also important to keep your communications succinct. If you are excerpting or quoting someone else's article in your communication, keep the excerpt short and relevant to your communication. Despite what newspapers and some PR companies say, newsgroups are really not for promoting business items, advertisements, get-rich-quick schemes, or other similar postings. Blatant postings to solicit customers are unequivocally condemned. It is acceptable, however, to mention a service, web site, local store, or company *in the context* of the rest of the articles posted in a newsgroup. Direct soliciting should be considered

. .

forbidden. Multi-level marketing schemes, form letters, and other such methods, are a major breach of netiquette. While the users of the Internet may not have direct control of what you communicate, the Internet is very quick to condemn that kind of behavior.

CROSS LINKS

Linking your web site to other related sites and directories is the first step in your cyberpublicity campaign. The ten words you chose earlier to describe your web site help identify which WWW directories and indexes your site should be linked to. You should post your site address to as many relevant directories and indexes as possible. I always encourage clients to post their web site address to the top five WWW directories. Currently these are: Yahoo, WebCrawler, Lycos, Info Seek, and Excite. It costs you nothing to post on these directories.

Surf the Internet to find other web sites similar to yours. There are many other sites that can serve as perfect *jump sites* to your own. Once you find a site that attracts a similar audience to yours, find the e-mail account of the *webmaster,* or the person who is in charge of running the web site. Send an e-mail to this person asking for a *reciprocal hyperlink.* A reciprocal hyperlink is like saying "You scratch my back, I'll scratch yours." Tell them that you will provide a hyperlink to their site if they provide one to yours. This is a great way to become known within your audience and narrowcast on the Internet. Having your web site posted at other popular sites similar to yours can make your site popular overnight.

NEWSGROUPS

The next major area to post your web site address is at UseNet newsgroups on the Internet. These are, as previously mentioned, very specific groups that are easy to subscribe to and post a message on. There is a discussion group for almost any topic imaginable. By analyzing the words and categories describing yourself, you should be able to find the newsgroups which are relevant to you. Some of these newsgroups reach hundreds of thousands of users every day, so make sure your postings are well thought out.

Once you have experimented with newsgroups, which is a prerequisite, you will notice that the most effective postings are *well-*

reasoned, logical, properly laid out, have *good grammar* and *spelling,* and *don't ramble.* Try to follow the same pattern. Remember, some users coming to the Internet via one of the other online services such as America Online or Microsoft Network, are paying by the hour to receive their newsgroup information. Nothing will annoy them more than receiving long and pointless postings. Keep this in mind when you write. Some subjects need many lines of explanation, but do not use up valuable space to say nothing.

Good grammar and spelling are sometimes difficult to maintain when typing quickly, but do try. Your presentation reflects the image and credibility which you have worked so hard to create. Construct sentences properly. An odd spelling mistake is easily tolerated; however, a message full of them will invite disdain. Make sure that you post informative messages to the group. Any message directly promoting your web site is not considered proper netiquette. If you do not know what netiquette is, I recommend that you read the above section.

In terms of netiquette, the best method of promoting your web site is to participate in an ongoing newsgroup discussion. At the bottom of each article you post, make sure your *signature* has your web site address. A signature is a several-line block of text that can be added to any article that you post on a newsgroup. Using signatures, as described above, is an accepted form of advertisement that will bring many people to your site. Do not just join a newsgroup and leave a message like, "Hi! My name is. . . . Come visit my web site at. . . ." You will suffer the wrath of that newsgroup. Become an active participant in the group's discussion and offer information to the newsgroup. Find ways of talking about your web site *in the context* of the newsgroup's discussion. You will get what you give. It is true that this kind of interaction may take more time than simply posting your web site address on a directory or search engine, but it will be well worth it.

CROSS-PUBLICIZE

As long as there is a physical world, do not ignore traditional means of marketing your web site address. Publicity should not exist in a vacuum and cyberpublicity is no exception. If you spend money to set up your online presence, then protect that investment by promoting your online web site address in brochures, at performances and shows, in

press releases, and the like. Start using your new web site address in your current advertising and on your business cards.

Mention your web site address in your radio spots, magazines, or newspaper ads. If you do it right, you will actually be adding value to your traditional publicity by enabling people to go to cyberspace to get more information on you. Such cross-publicity increases the value of your traditional advertising. Think about it; it would cost you a fortune to place all the information on your web site in print, TV, or radio ads. The promotion of your web site address on traditional publicity materials is like providing a physical hyperlink to your cyberspace billboard.

PROMOTIONAL OFFERS

Hold promotional offers on your site. Offer discounts on products or tickets for customers who visit your web site. Promotional offers are a way to continue the cycle of cyberpublicity on a regular basis. It will not be sufficient to cyberpublicize only once. By creating promotional offers or new features, you can have reason to continue the cycle of cyberpublicity.

GUEST BOOK AND E-MAIL

Internet publicity is based on feedback from your audience. This is a key difference from traditional publicity. *Guest book* and *e-mail forwarding* can give you feedback from your web site visitors.

A guest book can be a simple form containing fields such as name, address, phone, e-mail address, and zip code that you can ask web site visitors to fill out when they visit your site. Most visitors will not fill out such a form unless you either offer them something (promotional offer) or ask them a question that requires their input. You need to be clever and creative in getting people to fill out your guest book. You could, for example, give a visitor 5–10 percent off the price of tickets, CDs, purchases of art, or some other incentive for filling out the guest book. Guest book entries become a valuable resource. The entries become a mailing list of future clients.

Adding an e-mail forwarding link to your web site is a must. An e-mail forwarding link will allow visitors to contact you directly. Visitors can give their comments on your web site as well as feedback on the service or product you provide.

ACQUIRING DEMOGRAPHICS

Unlike traditional publicity and advertising, the Internet lets you know, numerically, how effective your publicity efforts are. The Internet maintains *log files*. These log files can be used to determine the number of unique visitors coming to your site. Each entry in the log file is stamped with the date, time, and IP address of a remote visitor. One big mistake made by many people is to count each entry in the log file as a unique visitor to the web site. Each entry in the log file records everything from the user accessing text to images; therefore, a single user requesting a single document might actually result in several entries in the log file as the document and images associated with the document are being received.

Suppose you run an art gallery on the WWW. You may have done all your cyberpublicity on WWW directories, newsgroups, and elsewhere. You are now interested in knowing how many unique users are coming to your site. You should ask your provider for the log file. When you get the log file, you can either get an expert to help you

analyze it or you can make estimates. Teaching you to analyze log files is beyond the scope of this book; however, there is one quick method of estimating the number of unique users.

First, decide how many images, on average, you have per page on your web site. Suppose there are ten images, on average, on each web page. If you get 10,000 entries in the log file, simply divide the number of entries by the number of images. This will give you a total of 1,000 unique users to your web site. This is an approximate method. If you do learn to read log files, you can ascertain which parts of your web site are heavily trafficked and which are not.

The most accurate way to find out the number of *hits* you receive per page on your web site is with a *page counter*. A page counter is simply a number which increments each time the page is viewed by the user. Because each page on the web site can have its own counter, you can easily see how many times each page has been accessed. You probably have seen counters throughout the WWW. Page counters have another advantage; they tell users how many people have visited your site. You can, therefore, build perceived value in displaying such information. Implementing page counters involves some special programming. You should ask an expert to assist you in implementing a page counter on your web site.

In addition to using log files and page counters, *forms*, such as guest books, are great for generating demographic information. How do you get someone to fill out a form? Most obvious is the fact that you can ask questions in a form, which a user fills out and submits to you via e-mail. You can then collate the information and use it any way you like. There are many types of demographics that you can solicit in this manner. You can ask questions about improving your site—whether it is too slow, whether it provides enough graphics, too many graphics, is it easy to use, or any other such questions. Internet users, in general, like to give their opinion. Once you get demographic information, you can use the standard methods of market analysis to understand your audience. A good database system can help in collating the information you received from your forms.

Cyberpublicity is both an art and a science. The above discussion has laid the foundations for cyberpublicity and should give serve as a guide for your Internet and marketing promotions effort. There is, however, a lot more to discuss in terms of the intricacies of effective marketing planning. I plan, at some point in the near future, to write a more complete document addressing these issues along with some software that will help you analyze log files and demographics more effectively.

Once you have built a web site and have executed a powerful cyberpublicity strategy, you may be ready to use your web site to sell products and services online. Setting up your web site as a retail storefront can result in more than just marketing and promotions value. Such a WWW retail shop can enable you to leverage your marketing efforts to gain financially by the direct sales to web site visitors.

SETTING UP SHOP

O nce you have your web site on the Internet
and have publicized it, it may be valuable
to use your cyberspace storefront to conduct
commerce. The Internet provides mechanisms for online transactions.
Artists and arts organizations are using their web sites to sell
merchandising, tickets, and even artwork online. In addition, many are
also realizing the use of the web site for customer service and support.

SUCCESS STORIES

Some of you may be thinking that it is a wild idea to sell products
and services and to service clients online. A few success stories will make
you realize that it is not:

> All Weather Inc. spent about $3,000 to rent space in an online "mall"
> to promote sales of a swimming pool alarm. In less than a year, it has
> received $500,000 in orders from around the world. (*Infoworld*)

> Federal Express and other firms have found a powerful model in using
> the WWW to service their customers. On the Internet, people can now
> check a FedEx shipment's status at any time, virtually anywhere, without
> the hassle of voice-mail menus, queues and other delays. (*Internet World*)

Digital Equipment Company sold over $15 million in product via its Internet site to customers in 1994. (*Internet World*)

PC Gifts and Flowers, Stamford, Connecticut, sold more than $4 million in 1994, selling through the online service Prodigy, with only 2 million members. Typical "hits" per day are between 25,000 to 30,000. Now consider that the Internet has over 30 million members. (*PC Week*)

PC Financial Network has accounts with assets totaling more than $2.8 billion (6/95) from 100,000 online consumers. (*PC Week*)

The Handel and Haydn Society, the oldest continuously performing arts organization in the country, is another success story. The Handel and Haydn Society was one of the first classical music organizations to get a web site, in early 1995. Deb MacKinnon, the Associate Director of Audience Development, decided to continue the Society's web presence during the 1996–1997 season. Why? Because it was a huge success during the 1995–1996 season. As Ms. MacKinnon points out: "Our web site paid for itself several times over in the number of ticket sales and orders we transacted from on-line leads. In addition, our organization was viewed as contemporary and cutting-edge as we reached out to new audiences for classical music. Most exciting was receiving e-mail from all over the globe. It has been a wondrous PR tool and will continue to be an integral part of our marketing campaign."

ORDERING ON THE NET

One of the main reasons that the Internet and the WWW are so popular is that they enable businesses to take electronic orders for products. The fastest selling items on the Internet are music CDs. This should be good news to musicians. Selling tickets and booking reservations also appear to be doing quite well on the WWW. Taking orders electronically can save money on printing costs, telephone time, and personnel.

There are two ways to take orders over the Internet and WWW: e-mail and WWW forms.

E-mail offers an effective means for taking orders on the Internet. Since e-mail is the most rudimentary service the Internet has to offer,

all 40 million users have it. When you publicize your product or service via UseNet newsgroups or your WWW site, ask those interested to send a check to your mailing address or to e-mail their credit card number, along with the expiration date, to your e-mail account. As e-mails come in, check credit cards for validity, place the orders, and send the user back some form of e-mail for acknowledgment. Using *listservers*, as described in the chapter "Intelligent Agents," you can create automatic response systems for users requesting ordering information.

Using WWW forms is another way to take orders. These interactive forms can be designed for the user to input data and information directly into fields. One advantage of forms is that you can e-mail the contents of a form to an e-mail address. Another advantage is that you can change the look and feel of your form any time, without having to notify anyone. HLML provides the ability to create forms. There are many books that can show you how to design forms using HTML.

CASH COLLECTION

Once you have an order, the next step is to determine how the customer will pay for it. There are three ways of collecting cash from the customer.

The first way to collect cash is by using credit cards. Most people are shocked to find out that they can make credit card orders over the Internet. People do transactions by phone or mail, so why not by the Internet? Credit card transactions via the Internet are not only possible, but are done every day. Credit card processing represents the easiest, quickest, and surest way of collecting cash on the Internet. In processing credit cards, the important questions are: how is the information being transmitted, is it safe, and who is clearing and validating the card?

Credit card information is transmitted by typing in the credit card number into a form and then sending that information in a encrypted format over the lines to the server (you) where the number is decrypted and made available for you to process. Credit cards can be either cleared and validated by you or by a credit card bureau. If you already have the capability to clear cards, then you are all set. If not, a bureau will charge somewhere on the average of 4 to 5 percent for processing the card.

The second way of collecting cash is to accept checks. While credit cards are more convenient, some people will refuse to use credit cards

over the Internet. This method is very much like normal mail. If you accept checks worldwide, specify that on your e-mail or interactive order form.

The third way of collecting cash is through purchase orders. This requires a bit more work, but essentially the customer enters their account number and a password. These two pieces of information are tied to a pre-established line of credit. You look up their account number and directly charge that account.

ORDER FULFILLMENT AND CUSTOMER SERVICE

Once an order has been processed, it is vital that the order be sent out efficiently and quickly. However, fulfilling an order over the Internet should not be any harder than filling mail or phone orders. If customer service is important, you can also set up a form-based system for your clients to check the status of their orders. Federal Express, for example, now allows you to check the status of any package using their WWW site. (Their WWW site has saved Federal Express millions of dollars by reducing customer support calls.) If you are an arts organization getting hundreds of calls requesting the same information, it may be worthwhile to design a customer service strategy for your web site. Chamber Music America, according to Dean K. Stein, the executive director, receives over four hundred calls a week from its nearly 12,000-person membership. Most of the calls involve requests for basic information. A web site with a FAQs (Frequently Asked Questions) section would help in reducing those calls.

Setting up and running a shop on the Internet can actually be easier than maintaining a physical storefront. Understanding the basic mechanics of taking orders, processing orders, and fulfilling those orders is the key.

DESPERATELY SEEKING

The Internet and the WWW can be used by artists to discover job opportunities in the real world. Many companies regularly post openings for both long-term and contract work on the Internet. In addition to using the Internet to find jobs, there are new jobs being created online. These jobs include titles such as *web master, web designer,* and others. These jobs and their titles are still being defined. There will be many job opportunities for visual artists, performing artists, and writers on the Internet.

FINDING JOBS USING THE INTERNET

The Internet is a great research tool. It can be used to research and find jobs. Many companies post openings for both full- and part-time work. There are various sites on the Internet that are dedicated to jobs. These web sites categorize job groups and offer simple job descriptions along with e-mail addresses and other contact information. Users can typically e-mail their resumes directly online. It's fast and easy.

For artists seeking jobs, the medium of the WWW is particularly useful and cost effective. Currently, most artists develop promotional kits (promo packs) or portfolios to send to prospective employers. Once these items are made, they are typically mailed. For artists who send

slides, photographs, video tapes, and CDs, the mailing itself can be quite costly. In addition, there is the actual cost of making copies of the slides, CDs, tapes, and other materials. Furthermore, nine out of ten times, an artist will never see their promo packs or portfolios again. The artist has no way of knowing if the recipient even opened the package.

An artist using the Internet as a medium of information transfer can benefit greatly. For example, in response to a job posting for a musician needed at a wedding, a musician can simply e-mail his or her web site address to the prospective employer. The prospective employer can visit the musician's web site and read about the artist, check out his or her biography and other relevant information. Most importantly, the employer can listen to his or her sound file. Similarly, painters and poets can e-mail their web-site address to prospective clients and receive immediate feedback.

JOBS ONLINE

One of the greatest opportunities for artists will be jobs created by the Internet itself. There is a fast-growing need for talented visual artists, performing artists, and writers on the WWW. You may wonder why. There is a need for real artists to build and design web sites as well as the future virtual reality (VR) cyber-landscapes of tomorrow.

Just look at a web site. Many sites have graphics, text, animation sequences, sound, and video. Someone had to design the page and create all those elements. Today, most web sites are designed by either non-artists or amateur artists who have learned a few computer graphics programs—and it shows. There is a lot of cyberjunk on the Internet. Many web sites are horrible looking, poorly designed, and have awful writing. This presents a great opportunity for artists. Currently, many web sites use clip art. The works of fine artists can add greater elegance and class to a web site.

Recently, the art director of *Esquire* magazine quit to start his own web page design firm. He saw the opportunity. Many performing artists are finding ways to use their skills to enhance web sites. Musicians are creating sound files and background music for web sites. Animators are creating fast, attractive animations for major corporations. The demand for visual artists is also growing. Clip art is used on most web sites; however, many WWW viewers love to see real art and illustrations

incorporated into a web site. Major corporations and businesses who want professionally designed web sites are eager to have their electronic buttons and logos custom designed by real illustrators.

This is only the beginning. As virtual reality develops, the entire spectrum of visual and performing artists and designers will be needed to create the cyber-landscapes of tomorrow. I believe those artists from theater will find the world of VR especially lucrative. Writers, poets, and storytellers also have much to gain. Interactive communication is infotainment and edutainment. Interactive writing is developing into a new writing form. Creative writers will be needed to weave stories and characters at web sites to make them fun and interesting.

GRANTS AND FUNDING ONLINE

For those seeking other opportunities such as grants and funding, the Internet will be an invaluable tool. I recently helped a budding filmmaker, a woman who is a student at the North Carolina School for the Performing Arts, find grants specifically for women filmmakers who were developing films on women's issues. The grant offered $1500 scholarships for one semester of school. She received all the material online and even sent in her application via e-mail, along with a reference to her web site URL address so that the scholarship committee could get a taste of her talents. The WWW search engines can aid tremendously in such efforts. Many funding agencies, both government and private, are developing major web sites on the Internet.

Again, for those wanting to use the WWW as a research tool, I recommend either taking a basic course in library science or information retrieval. If you can learn how to use search engines effectively, you will be able to gain a competitive edge.

COLLABORATION

Many artists work on collaborative projects. The simplest example is a lone guitarist looking for a band, or a band looking for a guitarist. The Internet can help make such connections possible. I urge artists with web sites to develop such collaboration by devoting a section of their web page to comments from fellow artists. You never know what kind of connections you might make with fellow artists halfway around the world.

Imagine that you are a local musician in Boston and you want to tour the local clubs in Amsterdam. Using the Internet, you could build a relationship with a fellow musician in Amsterdam via e-mail. You could share information on the respective local music scenes and even help each other book gigs. Ultimately, you may decide to do a reciprocal local tour. The musician in Amsterdam may come to Boston and you may go to Amsterdam. If you become friends, you may save money by staying at each other's home during your visits.

Collaboration of this kind can create new friendships and contacts around the world. Moreover, such collaboration can also result in the direct creation of art over the Internet. Such developments, called *collaborative art*, are also becoming commonplace on the Internet.

COLLABORATIVE ART

The Internet and the WWW can, no doubt, be used to promote and showcase one's art, music, dance, or writing. The Internet, however, can also be used by artists for the collaborative creation of art. *Collaborative art*, as it is being called, is booming on the Internet. The Internet offers performing artists, visual artists, and writers the ability to collaborate on projects that wouldn't be feasible in other mediums.

WHERE ARE WE?

Many major performing artists are beginning to experiment with using the Internet and interactive media for collaborative art. The *Rolling Stones*, for example, were one of the first major bands, in 1994, to perform a concert via the Internet. Performing artists such as Laurie Anderson have incorporated the WWW into part of their performances by having visuals and lyrics that were inspired and taken from the WWW itself. Although there is great potential, many people do not seem to be pushing the frontier of the WWW and its audio capabilities. One reason is the size of audio files. Normally, unless the audio file is small, there is some delay in downloading the file before it can be played. Developments in *Real Audio*, however, are offering alternatives. Using Real Audio,

one does not have to download the file; there is no delay. The audio file plays instantaneously. The Real Audio model of delivering audio files is going to become the standard as the quality of Real Audio improves.

Interactive video programs are pushing the current limits of what you can do on the Internet. Video artists have been slow to use the Web itself because of its limited interactive nature.

Currently, users of the WWW must request information one step at a time. For example, you can't load a page and a sound file at the same time. One or the other must happen first, and then you can move to the next event. However, Netscape's development of the PULL feature, allows one periodically to pull an image, sound, or document from a server. Bruce Padmore, a professional WWW web site designer, for example, has built an online web tour of his site, using this PULL feature. Someone visiting Bruce's web site gets an automatic tour without having to point and click. Pages, sound, and images are navigated automatically.

Past events on the Internet provide clues to the forms of interactive visual artwork that could be created on the web in the future. The IPI (Interactive Painting International) art piece that was created for the 1992 Siggraph Art Show in Chicago is just such an example. Featuring a huge video wall and artists from the United States and fourteen countries around the world, the system allowed the artists to paint together on a huge canvas, in real time. The artists were connected to each other through the Internet, and as each one painted, the artwork-in-progress instantly appeared on the screens of the other artists. Artists could paint on top of each other's work as well as send audio messages to other participating artists. The attendees at the Siggraph 1992 show could all see the art being created in real time on the video wall.

Some fine art supporters question the originality of such art. In the end, however, whether it is good art depends on the artist(s). Whether the art is original, depends on what is being turned out. Most people would consider a hand-signed, numbered, limited-edition lithograph or woodcut, original art. Similar consideration can be made when qualifying collaborative art that comes from a computer.

Writers and poets have participated in many collaborative projects. There is one web site on the Internet that claims to have the longest sentence in the world. If, by chance, you get on the Internet and can get to the URL address at *http://math240.lehman.cuny.edu/sentence1.html*,

you will see the world's longest collaborative sentence. This sentence has been constructed by thousands of writers and visitors to the web site. Visitors, writers and non-writers, can add to the growing sentence. It's a vivid example of collaborative writing.

SOME INTERESTING PROJECTS

Collaborative art is a new art form which, in years to come, will develop into its own discipline. There are various projects underway which exemplify such art. *Metamorphosis* is an the outgrowth of a project called *Openissimo* created by Flyvision, also known as Pierre de Kerangal. This project offers an artist the chance to *screen capture* one of the images supplied on Flyvision's *Openissimo* web page. Screen capture involves literally taking the image from the web site to the artist's local computer. Once the image is screen-captured, the artist can then alter the image using various paint and software programs such as Adobe Photoshop. Once the image has been creatively altered by the artist, he or she can the place the image back up on the *Openissimo* web page. The cycle can repeat. Another artist can screen-capture the altered image and add his or her own flair. On this web site, visitors can actually see the original image and the evolution of the image to its present state.

Kaleidospace's collaborative art project is designed to allow users on the Internet to co-create a story, picture, comic, video/animation, or musical composition with a well-known artist in Kaleidospace's Artist-in-Residence (A-I-R) program. The A-I-R provides the beginning of a story, musical work, video, or graphic novel to which Internet users contribute the next stage. The resulting collectively produced work will be displayed on Kaleidospace's WWW site, along with information about contributing artists.

An Internet-based creative community has developed around the OTIS online gallery, a worldwide community based on the exchange of images, ideas, and collaborative artworks. OTIS stands for *Operative Term Is Stimulate*. This online gallery is the creation of Ed Stastny, a student at the University of Nebraska at Omaha. It began as a repository of digital images created by artists to show their work from a variety of sources, both computer and hand generated. Today, there are images from dozens of artists encompassing a vast range of image creation techniques. The OTIS online gallery is a nearly two years old and has involved artists from

all over the world in different projects. Previous collaborative art projects at the OTIS gallery included *Crosswire* and *Arcana.*

Crosswire involved downloading an image, manipulating it, and then reposting it to the gallery. When an image had been manipulated three times it was declared "done." *Arcana* is a collaborative art project involving the development of a new computer-generated tarot deck. More recently, a different sort of unplanned collaboration has begun to take place at OTIS. On weekends, after midnight, artists meet on the Internet Relay Chat (IRC) channel #OTIS. During the IRC chats, they exchange images in real-time sessions that are freewheeling interchanges, interactions, and collaborations. Artists also explore two- and three-dimensional image manipulation in a real-time immediate exchange format over the Internet. These sessions rarely end before sunrise and usually result in hundreds of new images, evolving in a spontaneous, wildly creative fashion. The products of these collaborations are available for viewing and downloading at the OTIS online gallery.

We are still in the early stages of the development of collaborative art. The above examples are only some of the hundreds of web sites developing collaborative art projects. Other projects, such as the University of Hamburg's *HyperArt* project, Syracuse University's project *Digital Journeys*, and the various OTIS online gallery projects, are leading the way in exploring the future of this new visual art form. Other visual artists, performing artists, and writers will continue to explore this art form and create new vehicles of collaborative expression.

Collaborative art can also take the form of an art teacher instructing students online. This type of collaborative art, referred to as *distance learning*, is also becoming popular. Several colleges and universities are now providing "cybercourses" and "distance degree" programs over the Internet.

DISTANCE LEARNING

Distance learning is gaining greater acceptance as an educational tool. For artists, it offers a way of sharing knowledge with a worldwide audience. Imagine teaching dance, theater, or art to a student thousands of miles away. Such experiences will become a reality as artists learn to take advantage of the Internet.

WHAT IS DISTANCE LEARNING?

There are some great terms that have been used in distance learning, including: *telecommuting, video on demand* (VOD), and *the interactive classroom*. Distance learning refers to a teacher and student who are not at the same location. It can take many forms such as: teaching a class at a distant location while simultaneously teaching class at a real physical location; teaching by one-on-one videoconference; student access to remote teaching materials; or student access to remote laboratory equipment or simulations.

Videoconferencing, in conjunction with a shared whiteboard, has proved a powerful mechanism for teaching students at distant locations. Some have used videoconferences to teach the elements of the HTML "language" to teachers and students who can now build their own web sites.

TELECOMMUTING

Telecommuting means working from home. A telecommuter travels to work by telecommunications rather than by car or bus, resulting in a savings in time and decreased pollution and traffic congestion. Oliver McBryan, for example, works at the Computer Science Department of the University of Colorado, in central Boulder, and lives in the country outside of town. He enjoys "a magnificent view of the Indian Peaks, a range of 13,000 and 14,000 foot mountains." He has an ideal environment for telecommuting given the speed of the network that he uses. When he wants to access a remote file or network resource, he uses the university's T1 line to the Internet—shared by all 25,000 people on campus. Videoconferencing has become a critical part of his telecommuting because it allows him face-to-face contact with colleagues and students, and the ability to share documents. He routinely conferences with graduate students.

VIDEO ON DEMAND

▶ 120

Video on demand is a much touted aspect of the information superhighway. Those using web browsers such as Mosaic or Netscape are likely to be familiar with both audio and video on demand. The biggest problem is that data rates are too slow. There are two solutions. On the one hand we can speed up network access rates. The second solution involves better image compression. Most current video on demand uses the MPEG standard, which provides excellent compression but requires expensive computations to decompress the image before display. Currently almost all systems on the Internet use software decompression which limits the frame rates that can be achieved.

DISTANCE LEARNING FOR THE ARTS

Distance learning provides educational opportunities in a different way than the conventional classroom. Distance learning has been tested and proven in practice, which has many advantages. A musician friend of mine recently told me that he was one of the select few who were given the opportunity to take guitar courses from the famed guitarist Joe Satriani. Joe was apparently known as the "Guitar God" in his Oakland, California neighborhood. When this friend moved away to the East Coast, he could no longer take classes from Satriani. With the technology

available today, my friend could live in Boston and learn to finger pick from Satriani by distance learning.

The Minneapolis College of Art and Design (MCAD) is a cutting-edge institution which has taken the lead in developing a range of arts courses, via distance learning on the Internet. The main requirement for taking the courses, which are limited to twelve students, is that students have access to the Internet. In addition, the course syllabus states that students will also need to arrange "online discussions and meetings" with their instructors.

MCAD offers various courses, including *Art on the Internet* and *Drawing for Electronic Media*. The first course explores telecommunications as an art form. The course focuses on art that is being made expressly to be experienced on the Internet. Through assigned and self-generated projects, the class investigates many of the possibilities and offerings available on the Internet. Students look at the new role for the artist working in the new environment of the Internet. The course covers the nature of "hypertext," and encourages nonlinear interactions.

Students in this course learn that unlike traditional books, which must be read from beginning to end, hypertext allows for numerous ways to "read" information. Part of this course includes "net surfing," exploring, discussing, and critiquing interactive "web art." As a class, the students make electronic visits to many web sites to view exhibitions, museum and gallery collections, and to build a resource list of sites that share mutual interests.

Each member of the class also develops an interactive, hypertext project that will be displayed as part of a collective web page exhibition. Students develop projects and perform class activities from their individual locations and communicate with the instructor and members of the class by computer. In this new Internet environment, the class "meets" weekly in a conference format, where assignments and discussions are posted, and students are required to complete weekly assignments.

MCAD's work on distance learning is growing evidence of using the Internet not only for teaching in general, but specifically for teaching art. This is what is so exciting. Artists and art teachers can take advantage of MCAD's experience to develop their own courses that can be offered directly to a global audience over the WWW. There are many visual art and performing arts teachers whose skills and talents have only been

available to a local clientele. With distance learning, their talents could be made available to a global clientele.

BENEFITS OF DISTANCE LEARNING

Through distance learning, or *telelearning,* students can learn at their own pace, without the extreme competition of traditional schools. National education centers, for example, could set standards for virtual classes, programs, and projects to ensure the same level and quality of education, while offering a completely personalized curriculum. Personalized curriculums can actually be made cost-effective with distance learning.

Schools that in the past were too poor to provide proper equipment, will instead enable users to simulate their experiments and equipment needs. Computers could, for example, simulate chemical reactions calculated on substances that a student mixed. Art students could learn color theory from mixing paints on a virtual canvas. Lighting designers could teach the intricacies and art of stage lighting. Writing students could have expert prompting systems at their disposal to help them improve and experiment with their style. History departments could reenact famous political situations, enabling students to witness them from opposite viewpoints and experiment with outcomes and scenarios.

With distance learning, students would no longer have to go to class in school buildings. Bussing and school overcrowding would no longer be problems. No matter where the student lives, the Internet offers the potential for that student to receive a quality education through one-on-one interactions or group learning.

DISTANCE DEGREES

The University of Memphis offers a master's degree for journalism students. Students north of the Mason-Dixon line can get their degree without ever having to venture south of New England. The virtual classroom eliminates the barriers of geography. Distance education typically doesn't require all the participants to communicate at the same time. That is especially important, given the target audience for the next decade. "In the year 2000, the majority of students will be over twenty-five years old," says Jacques Dubois, Director of Distance Learning at Brevard Community College (BCC) in Cocoa, Florida. BCC has just

begun offering online courses leading to an associate's degree. People with disabilities, workers on irregular shifts, frequent travelers, single parents, residents of isolated areas, or people who want to study in a specialized area without moving, can take BCC's courses without having to change location.

No one can reliably estimate how many colleges, universities, vocational schools, and other programs offer online classes or other forms of distance learning. The Distance Education and Training Council in Washington, estimates that about 3 million students are registered this year in council-accredited programs, in subjects from accounting to zookeeping. Both credit and noncredit offerings are on the rise, but full-degree programs remain relatively rare. According to a recent study of 230 colleges by the American Association of State Colleges and Universities, half of the schools surveyed offer "cybercourses," but only about 10 percent provide *distance degrees*. Educators universally predict an increase in that figure over the next few decades.

Beyond the initial investment in equipment and instructors' salaries, costs are low, enabling many programs to offer virtual classes for lower tuition than traditional, face-to-face courses. Over the next semester, Brevard Community College's online offerings will jump from a few business and astronomy classes to more than twenty-five courses in a range of disciplines. The World Community College mirrors aspects of BCC's real-world campus. It includes a virtual student lounge, bulletin boards, study groups, faculty and adviser office hours, a student newspaper, and a bookstore—all online.

Many skeptics wonder whether the convenience gained in distance education is worth the loss of human interaction. Another concern is that the format adds a layer of difficulty in determining who is actually doing the course work. However, the instructors say they get to know students' online personalities as well as they would their faces and voices in a traditional classroom. BCC, moreover, requires online instructors to hold at least one proctored examination, in person, per term.

Thus, while there are various unresolved issues, distance learning appears to have a bright future. Distance learning will continue to evolve with the Internet. Future technological advancements in the Internet, moreover, will provide new possibilities for applications such as distance learning.

NEW POSSIBILITIES

The future of the Internet seems to be quite promising. What we have seen today is just the beginning. The future holds new ways of interactive communication and presentation of multimedia information that will make each of our computers a literal broadcasting station capable of sending live sound, graphics, and video in a collaborative real-time environment.

THE INTERNET'S FUTURE

It seems that the Internet is developing at such a rate that whatever is written about its future quickly becomes its present or past. By the time you read this chapter, the technology or tools described here as part of the Internet's future may have already been created.

The current WWW browsers, while powerful, have certain limitations. In the future, the Internet will have new text processing features, overlapping elements, interactive user input features, real-time interactive and 3-D capability. Such features will make the WWW more robust and also more widely useful. Text flow will be improved so that one will be able to place pictures anywhere and have text flow around it. Overlapping elements will enable more artistic use of the WWW. Being able to place text or pictures over other pictures will create the

means for information to be presented in new and novel ways. More intelligence and more options in the handling of interactive user input will appear. Buttons that are animated when pushed, and WWW forms that are intelligent in receiving user inputs, will enhance day-to-day use of the WWW.

WWW browsers, in my opinion, will become the operating systems of the future. This is why Microsoft is so concerned with Netscape. Netscape's browser *Navigator* could replace Microsoft Windows itself as the user-interface of choice, not only for WWW browsing but for general browsing and execution of programs on your local computer. Imagine turning on your machine and Netscape *Navigator* is the de facto user interface you see, not Windows 95 or some other windowing interface. That thought sends fear into many of the creators of major operating systems, especially Microsoft.

The ability to interact in real-time will become more prevalent. Unless one has Real Audio or Real Video capability, one must download a sound byte or video clip, wait, and then play it locally. This will not be the case in the near future. Audio and video will be seen in real-time as these tools become cheaper. Interactive sessions such as chat and video conferencing will be made more accessible within web sites. Such developments will enable visual artists, performing artists, or writers to broadcast right from their homes or studios to their fans and clients. They will be able to present entire performances or shows using this technology. Most interesting is that the WWW will become three dimensional by enabling objects to turn and rotate automatically or by user control. This capability will support new developments in virtual reality (VR).

VIRTUAL REALITY

Imagine having your own dance performance and inviting people from around the world to participate in it, live? This will be possible in the near future. Currently, the hardware to implement VR (such as helmets and input gloves) is clumsy to wear and the images are less than real-world quality, but improvements are being made. There is an emerging trend to create *immersive spaces* as a solution to having to wear clumsy helmets and other VR paraphernalia. An immersive space, or *cave*, is an environment one walks into—similar to the "holodeck" on

Star Trek. While in this cave, the user is an interactive participant who can communicate with users in other caves halfway around the world. Text, images, sound, and video are combined to create an interactive experience for the user and other participants.

A total virtual-reality interface to the WWW will certainly open up new business opportunities for many artists. Someone will have to create the virtual landscapes, buildings, sounds, and movies that will liven up the new VR landscapes. Artists should take this seriously. There will be major opportunities to contribute and make money from VR projects and web sites—sooner than you think.

As people rush to create their unique identity, businesses will emerge to develop virtual products for customers to wear and use in virtual web space. You will not use a mouse to surf, instead you will be transported to a business, in which you can walk, talk, meet, touch, and purchase. Fashion designers, costume designers, and others who work backstage in theater arts, will find VR filled with opportunities. One day, you may consult a VR fashion designer before making your next trip business trip in cyberspace.

127 ◄

LIVING INTERACTIVE

As the Internet and the WWW evolve and begin to influence society, your lifestyle at home will change substantially. The WWW already offers far more content than all the broadcast and cable television stations combined. How often have you checked the TV listings only to find that nothing is worth watching on any of the 140 or so channels? On the WWW, something is always happening. There are new web sites coming online every twenty minutes. Perhaps this is why Internet users watch 25 percent less TV.

Because of this variety and vastness of content, the next level of integrating the computer into our society will be to have the WWW in our homes. If such integration is not done by computer and telephone line, then it will be done by cable or optical fiber, using television that is driven by Internet content.

When you venture outside, you will probably take a portable tele-communications device that will enable you to stay attached and communicating at all times. This device will serve as your phone, television set, watch, and supercomputer. Just as now you don't think

twice about putting on a digital wristwatch, in the near future you will not think twice about slipping this new device into your pocket before you walk out the door. This device may be your future "wristwatch" but one networked globally with its very own IP address! Such a device may not be that far off. NETCOM and MCI, for example, have already made it possible for people to receive and to reply to e-mail using a hand-held pager.

VIRTUAL OFFICES: TELEWORK

A year ago, Information Cybernetics, Inc., a high-technology company and supporter of the arts, was planning on getting three thousand square feet of additional space for expansion. They decided not to. The company was in the Internet business. It did not seem right for them to set up the same old industrial structure of work if they were preaching that their clients join the interactive revolution. They chose, instead, to create virtual offices and began to participate in *telework*.

Using e-mail, phone systems with call forwarding, and the WWW, they kept their small, five hundred square-foot headquarters and encouraged their staff of thirty to work out of their homes or wherever they wanted. At its headquarters, the company needed only two people. The system worked well.

Most of the employees started their day by consulting an online appointment calendar on the WWW, which was also available to other staff. The commute, rush hours, and pollution were avoided. The impact on the environment was significant. The productivity of the staff increased. No one wasted time at the water cooler, in cars, or going out to lunch. Many were able to get a healthy home-cooked meal from their own kitchen. The morale of the company increased, since people had more time to spend with their families. Finally, the company saved large sums of money by reducing the need for rent and other overhead.

Did the new virtual office reduce the sense of camaraderie or closeness between employees? Absolutely not. When there are face-to-face meetings, the staff is productive. One staff member said, "When someone asks, 'How's it going?' when we meet, that question really means something more than just the words you say in passing on the way to the restroom."

Working in a virtual office environment demands responsibility and

commitment on the part of everyone. As Ronald K. Goodenow, director of the Telework Initiative at the Institute for Policy and Social Science Research at the University of New Hampshire, echoes, "These systems are not going to work unless people are really committed to what they're doing." Thus, in many ways the companies and organizations that will succeed in virtual office environments will have people who enjoy what they are doing and are committed to their work or telework. Working successfully in these new environments will also require new technologies for managing day to day communications. *Intelligent agents* will be among those technologies.

INTELLIGENT AGENTS

For many artists, the term *agent* refers to booking agents, performing arts managers, arts consultants, and the like. On the Internet, the term *agents* refers to software programs that find information, respond to information, or translate information. The term *intelligent agents* refers to those tools or programs that do these tasks with greater ease and intelligence.

WHY ARE INTELLIGENT AGENTS NEEDED?

Given the sheer volume of information on the Internet, it is becoming more and more imperative to find what your are looking for and to have what you are looking for find you. The features of the Internet encourage the exploration of information. Thus, many people find themselves hopping from site to site on the WWW. With new sites coming on the Internet each day, how will anyone intelligently find sites that are useful? While exploration of information can be fun and entertaining, it can be time consuming. Technological developments are creating software programs and other tools called *intelligent agents*, which not only to explore information, but also function almost as a personal cyber-secretary. Given the sheer volume of information on the WWW, intelligent agents will become an integral part of our daily life in cyberspace.

From the artist's point of view, intelligent agents are your servants. These servants can make connections for you and provide you with advice and other useful information, without taking a 15 to 60 percent cut. These agents can send you specific information on a daily basis, take care of your correspondence, and even find new opportunities for work.

WHAT INTELLIGENT AGENTS CAN DO

Today, those on the Internet spend hours surfing and finding information. For artists and arts organizations running on tight budget, surfing on the Internet should be a means and not an end. Intelligent agents can make your online time more efficient. Intelligent agents, moreover, are not new to computing; the Internet has had such agents for some time. The first intelligent agent was the *listserver* or a *mailbot*.

A *listserver* is a program hooked up to an e-mail address. Sending e-mail to the address activates the program, which looks at your e-mail message and fulfills requests it finds in the message. The nearest equivalent to a listserver in the real world is perhaps fax on demand (FOD) systems. FOD is implemented in various ways; in the simplest case, a prospective client dials the phone and requests a fax by talking to a human being or using the buttons on a touch tone phone.

FOD is a wonderful marketing tool; however, it costs several thousand dollars. A listserver, on the other hand, can be set up for about $100 and run for $50 a month, or less. Using a listserver, you can set up a catalog of your art work, list upcoming performances, list your writing, etc., and automatically respond to fans or prospective clients who e-mail you at the listserver address. This can save you the time of sending a hand-crafted e-mail message to everyone who calls you. The listserver can become your electronic clearinghouse for sending out standard information to prospective clients.

Another type of intelligent agent is a *search engine*. Earlier, we talked about WWW search engines. They are one type of intelligent agent. Search engines were developed to find things on the Internet. There are many search engines on the Internet today. Typically, most search engines request a keyword or a series of keywords. When you type this keyword, the agent searches the Internet or an index and attempts to find all sites on the Internet which have that keyword. Archie is a search

engine for finding files. Other search engines include WebCrawler and Alta Vista. The problem with current search engines is that they are keyword-based. This means that they search web sites for a particular word. While this will obviously return lots of documents with the word in it, many of those documents may be irrelevant. In the future search engines which perform searches on *concepts*, not just words.

One of the most important intelligent agents being developed is the *cross-language translator*. This agent will be similar to the "universal communicator" in *Star Trek*. Such agents will break down the walls of language. Furthermore, people will not have to learn English. Such technology will have great ramifications for maintaining both cultural and linguistic heterogeneity.

Other intelligent agents appearing on the market are being called *information filters*. These filters are enabling people to receive personalized information, automatically, without having to do manual searches using search engines. Every day new web sites are being developed. Wouldn't it be great to receive a list of all the latest web sites that just went up? Or how about a list of those web sites that were about dance, photography, or jazz? Or what about a list of paintbrushes that went on sale worldwide? Information filters will automatically deliver such information to your computer every time you log on, based on your personal tastes and profile. Such agents can make one's online time far more efficient and worthwhile.

IRRESOLUTION

SECURITY

All over the world, people are taking more precautions to keep themselves and their property safe. The Internet and the WWW are not exempt from these problems. As time goes on, and the Internet becomes more complex and populated, you can expect to see more and more people looking for ways to use the Internet dishonestly. As Nicholas Negroponte points out, "The next decade will see cases of intellectual property abuse and invasion of our privacy. We will experience digital vandalism, software piracy, and data thievery."

KNOW THY ENEMY

The Internet is a huge place that hosts over 40 million people. Unfortunately, not all of them are honest. Statistics show that only 10 percent of computer crime is reported and that a mere 2 percent of computer crime results in convictions. Losses from computer crime rose to more than $60 billion in 1995. Given the growth rate of the Internet, these numbers will only get worse.

There are some fundamental issues, myths, and truths behind crime on the Net. There are two basic types of criminals: soft criminals and

hard criminals. Soft criminals are like kids who ring doorbells and run away. They do things to see how far they can go without being caught. They are not seeking to do damage or to steal, but are merely seeking knowledge of how things work and are going about it the wrong way. Hard criminals use the Internet and the web to profit illegally. Such criminals often know all sorts of ways to hide their activities and may even band together to share the fruits of their illegal endeavors.

Generally, you do not need to be concerned with the first type of criminal. These soft criminals typically get tired of their games and soon stop creating mischief. The second group, the hard criminals, are a threat. A system as large as the Internet is not completely secure; it does have holes and crevices that a hard criminal can take advantage of.

Within the group of hard criminals, the worst criminals could be those within your organization. A friend of mine who owned a major telecommunications company contacted me to help him with a security issue. He had an employee who set up his entire computer network. One day, this employee demanded that my friend immediately fire someone

else in the organization or he would leave. Obviously, my friend, the owner of this $100 million company, was not going to be bullied, and he refused to fire the other individual. A few days later, the employee who made the demands left. He left with various secret passwords into the entire company's computer system, without any documentation or logs. It took a lot of money and time from security experts to close "holes" and "backdoors" this individual had left in the computer system.

After investigation, the individual who left was found to have a history of joining a company and leaving if his demands were not met. He had a history of using his knowledge of his employers' computer systems to make demands for salary raises, increased stock options, and other benefits. The lesson here is that your worst enemy could be someone already within the organization. The solution is to do thorough background checks on the individuals you hire to maintain you computer systems. Are they ethical? What do their previous employers say about them? Questions like these could prevent major security breaches.

Before you can begin to appreciate the specific crimes, you need to be familiar with some terms used by the criminals themselves. The media often uses the term *hacker* and uses it inappropriately. Hackers prefer *cracker, phreak, phracker,* and *pirate* as the proper terms for people who

participate in illegal activities involving computers and telecommunications systems.

A cracker is someone who breaks into computer systems by bypassing or guessing logins. Such criminals are a severe threat, because if they can gain access as a privileged user, they have access to incredible amounts of billing information, credit card numbers, and other highly personal data.

Phreaks, sometimes called *phone phreaks*, are people who hack phone systems. These people are specifically trying to scam long distance time, break into voice mail systems, or accomplish other phone related intrusions.

A phracker is a combination of a phreak and a cracker. A phracker breaks into both phone systems and computer systems. A phracker specializes in total network destruction. Generally, phrackers tend to be worse than phreaks because they have more knowledge of advanced systems. Not only can phrackers bypass phone systems, they can also bypass computer systems.

Finally, data pirates tend to be computer oriented. Their forte is **139** ◄ stealing commercial software, modifying it to run without needing serial numbers or other startup keys, and posting their data in *warez sites*. A warez site contains stolen software set aside for the downloading pleasure of all the pirate's friends and clients. Pirates place most warez sites on an innocent company's computer. This makes it hard to catch the pirates. This is similar to real-world pirates stashing stolen treasure in someone else's house or land and getting the treasure secretly when it is convenient.

COMMON CRIMES

There are three general types of crimes:
- Misrepresentation
- Theft
- Illegal Transactions

Misrepresentation and fraud are sure to grow on the Internet. One of the reasons that misrepresentation will become a problem, is that on the Internet it is so easy to appear as anyone or anything you want. The Internet, as mentioned, in the chapter "Crossing Lines," is a great vehicle

for breaking down discriminatory behavior, because one does not have to reveal the color of their skin, or handicaps. The Internet is also a way for local businesses to sell their goods and services to a global audience. Unfortunately, these same features of the Internet also enable criminals to hide themselves, or to present themselves as someone they are not, or to sell something that isn't what they claim it is.

Creating a scam web site, for example, is possible. Fortunately, it is not as easy as it might seem, because the scam artist has to place the web site at an Internet provider's computer. Most providers know whose content they are hosting and frequently examine sites, since they have direct access to the information. Thus, it is relatively easy to use the URL to trace the criminal right to the provider's door.

Theft can take many forms on the Internet. Phrackers or pirates can break into a system and take space on that system for themselves. Also, they can gain access to your system, steal credit card numbers, and use them to make illegal purchases. Another form of theft is to steal someone's access code in a private WWW site, log in as that person, and either steal, modify, or destroy data.

Intercepting communications between servers is yet another form of theft. This type of computer crime is perhaps the most feared, but is actually quite difficult to commit. The other, previously mentioned forms of theft are more common.

Finally, *plagiarism* is also a form of theft on the Internet. Taking text, sound, images, or movies which are in the public domain, and using them without proper credit or permission, is illegal. This type of theft is simple on the Internet, where copying a file is a matter of a click of the mouse and a few seconds of time. The web itself is especially vulnerable to plagiarism attacks. If plagiarists see a neat graphic or technique at a site, they can easily copy or "borrow" it.

Illegal transactions are a totally different type of crime. There is a huge cry for servers that will make credit card transactions safe. But safe for whom? Although such servers might protect consumers from having their credit card information ripped off in midstream, they would do nothing to protect the store owner from criminals who use fraudulent credit card numbers or false identities. However, this exact same problem exists in the physical world.

PROTECTION

Fraud and misrepresentation can be avoided in several ways. First, a company trying to commit fraud usually does not take time to create a proper cover. If you are shopping at a company, glancing at the URL can often be most revealing. Most large and medium-size companies have their own domain names. Likewise, companies committing some type of fraud usually have little noncomputer access information, such as telephone numbers and addresses. Most legitimate companies advertise as much as possible and give e-mail, fax, phone, and address information. An 800 number is a good sign. If you are unsure of a particular business' stability, simply call the company's area code and check whether the business is listed in directory assistance. A call to the company itself can tell you a lot.

Everyone seems to fear having their credit card information stolen when they type it into a form requesting the card number on the Internet. Often, users type into a field and then continue their sessions. If the user then leaves the computer turned on and unattended, anyone who walks by that computer can go back to the web page that required the credit card number and steal it.

To avoid this problem, two solutions are available: do not leave your computer unattended in a public space, or request that the field for credit card entry is a password field, so that the number is never visible on the field when typed in. If your material has been plagiarized, you should do the following: if you have not already done so, immediately register the material with the Register of Copyrights, Copyright Office, Washington, DC 20559. Document the theft's occurrence, so that you have solid proof by printing out the web page where the plagiarized material is hosted; also, document the originality of your work by showing the dates and times are earlier. With the proper documentation, simply call the offending party and inform them that you have ownership and that they should immediately halt usage of your material. If this does not work, simply take it to the offender's lawyer. With the proof, you should be able to obtain a settlement.

One of the simplest ways to safeguard against illegal transactions is to have your order-entry system checking credit card numbers against the credit card checksum standard. You can run this algorithm on any credit card number to determine whether it belongs to the valid sequence

of numbers. Although the algorithms do not tell you whether the credit card is *really* a credit card, at least it prevents people from typing 11111111 as a credit card number and having it work.

Perhaps the best way to ensure that transactions over the Internet are protected, is to make sure that there is a secure server. The most secure system is one that transmits information in an *encrypted* format.

ENCRYPTION

Encryption is a technique for hiding data so that it can be seen only by those for whom it is intended. Simple encryption schemes exchange one character for another. For example, the word "dcnngv" is an encrypted form of the word "ballet," where each letter in word "ballet" has been incremented by two to create the encrypted form. Obviously, this type of encryption can be broken, and is not very secure.

Today there are much more complex encryption schemes that are virtually impossible to break. Thus, keeping data encrypted is a great way to secure that data. The encryption of digital documents ensures that sensitive information cannot be decoded even if messages are intercepted. This encryption is now available for the transmission of credit card and other information. The technology can be used in the same way for the transmission of sensitive environmental information. The Internet's de facto standard for encryption is PGP which stands for "Pretty Good Privacy." PGP lets you encrypt a message so that only the intended recipients can read it. There are also protocols that allow a message to be signed so that recipients can verify that it came from the supposed sender.

▶ 142

PGP is available for a range of platforms, including DOS, Macintosh, and UNIX. Encryption works by using coding and decoding keys, copies of which are (securely) sent to people whom you want to allow to read your encrypted messages. There is some doubt about the legality of using public domain versions of PGP outside the United States, however commercial versions are available. Encryption is increasingly being used on the Internet for banking transactions. First Virtual Bank, an Internet bank, uses this technology.

There are a variety of other technological solutions available that can give web users a measure of security that had been lacking earlier. Several WWW graphical interface providers, such as Netscape, are developing

secure transmissions on the World Wide Web. Secure HTTP is an interoperable extension of the WWW's existing HyperText Transfer Protocol that provides communication and transaction security for WWW clients and servers. Secure HTTP works by a user clicking a "secure submit" button which causes a client program to generate encryption for the information on the form using the client's public key. The Netscape web browser provides an encryption system called *Secure Sockets Layer* (SSL), based on the RSA Data Security's public-key algorithm, to scramble sensitive data. Basically, the SSL is a protocol layer that sits between the TCP/IP and HTTP protocols. There are several other similar protocols available, and a committee of the W3C Consortium is looking at developing standards for the incorporation of authentication, message integrity, and privacy.

BREAK IN?

The best way to know if someone has broken into your system is to see if your information has been damaged. If you notice that there are garbage characters, missing pictures, or any displaced elements, it is likely that either security has been breached or your provider has had a major problem.

143 ◀

You should insist that your provider or service bureau routinely check disk space usage, communications lines, login files, network statistics and logs, and, most importantly, that your provider have *firewalls* and *wrappers*.

FIREWALLS AND WRAPPERS

When shopping for a service provider or a service bureau that will host your web site, you should always ask them if they have either firewalls and wrappers.

Firewall is the name used to describe either software or hardware that protects *ports* and keeps pirates from penetrating security. Ports are access points to your computer. The function of a firewall is to allow only certain trusted domain names to access your system. Other domains simply get a "connection refused" message. By restricting the millions of domain names so that only one or two get in, you are instantly restricting access to your system from the outside.

Firewalls are not good for a web site because you want people to visit

your web site. Firewalls are good on the FTP and Telnet ports because these are the ways in which intruders can cause serious damage by getting direct access to the data on your web site. Firewalls do little, however, to keep pirates internal to your system at bay or to keep out pirates sophisticated enough to fake a trusted domain name.

Wrappers, the second line of defense, help to address this problem. Wrappers are available from the CERT site. CERT was created in 1988 by DARPA to address computer security incidents. CERT is currently run out of Carnegie-Mellon University in Pittsburgh, Pennsylvania, at *cert@cert.org*. Wrappers run as a layer of software around other software. In other words, a user FTPing to you would first get the wrapper, which would then engage the real FTP process. The user does not know that the wrapper exists and cannot detect any difference in the system. In other words, wrappers can act as firewalls and actually refuse users based on their login names. Wrappers can be used to keep out the known criminals. Set up correctly, a wrapper can be a pirate's worst nightmare.

New laws to regulate the Internet are in the works. We are entering a period of major confusion and infighting within the legislative branches and courts in the United States and abroad, as the new freedoms of the Internet are ironed out. The most critical issues facing the courts with regard to the Internet are: what does privacy mean? What does copyright mean? How can we handle the fact that there are no national boundaries? What differentiates obscenity from art? We explore each of these issues in the subsequent chapters.

Many court battles have already begun. As they continue, laws will come and go. The real issue will be who creates the new laws: will it be a few politicians or the citizens of the Internet? I favor the latter. The Internet has a social etiquette that has developed without government intervention. Perhaps this organic force will be the basis of the new laws.

CENSORSHIP

C ensorship is one of the most controversial issues on the Internet, followed by copyright. In this chapter, I offer a vantage point to view this issue not from the left or the right, but from the view of recognizing that art is as powerful as science and technology.

ART IS DANGEROUS

My friend Rick Barry is a visual artist. Rick's view on censorship and artistic freedom is perhaps as cogent and well thought out as any I have heard to date. Rick does oil painting on canvas and also high-end digital art on the most advanced computers. In fact, Barry did most of the animation in the movie *Johnny Mnemonic*.

Several years ago, there was great uproar about an exhibit of Robert Mapplethorpe's photographs. Conservatives denounced Mapplethorpe's work as vile and degenerate. They said it should not be allowed in public. Liberals, claiming an attack on artistic freedom, demanded that Mapplethorpe's work be open to the public. Barry's stand on this issue can be summarized in a few words: "art is dangerous." If artists do not recognize that what they create is as powerful and as dangerous as what

a physicist or computer scientist develops, then art will always play second fiddle to science and technology. It will play this secondary role as long as one views a scientific creation as more important and more relevant than an artistic one. Let us all agree that art can be dangerous, in considering the issue of censorship.

A society would never allow me to build an atom bomb in my basement and then show it off to everyone in the neighborhood. Within hours, the FBI would be at my house and have me in jail. What is the difference between art and science? The creative ideas and thoughts of art and science come from the same powerful wellspring of imagination and creativity. Artists, Rick felt, devalued art and their work by simply screaming "artistic freedom" during the Mapplethorpe incident. Yes, there should be freedom of exploration in both art and science; however, the products of that exploration need to be seen as powerful, and individuals should have the right to decide how those products are promoted and distributed. That decision is the inalienable right of individuals per the Bill of Rights. How that decision is made and enforced should be the real issue.

► 146

WHO REGULATES?

When it comes to censorship on the Internet, the issue rages on in the same way. Who will censor: government or people? Will the decision come down from some government organization, or will it be the result of political demagoguery of some left-wing or right-wing politician? Or will the decision be made on the open forum of the Internet? This is the real question.

Howard Rheingold says:

> Don't be fooled when some politician uses "pornography and pedophiles on the Internet" as an excuse to cripple the most valuable technology America has going for it. It would be a mistake to let the censors create an infobahn police force. We might be trading precious liberties for illusory protection.

I think we have to think about ways of protecting children and society from the easy access of every kind of abhorrent information imaginable. But the "censor the net" approach is not just misguided morally; it's

becoming technically and politically impossible. As Internet pioneer John Gilmore is often quoted, "The Internet interprets censorship as damage and routes around it." If we were to agree to clamp down, does the United States have the troops to send to Finland or Kazakhstan to prevent people from putting pornography on their local tributary of the Internet? I don't think so.

The Internet, as mentioned earlier, was designed to withstand nuclear attack. The Rand Corporation designed the network to be a decentralized command-and-control-and-communications system, one that would be less vulnerable to missiles than a system commanded by a centralized headquarters. This decentralization of control means that the delivery system for salacious materials is the same worldwide network that delivers economic opportunity, educational resources, civic forums, and advice on health. This technological shock to our moral codes means that in the future we are going to have to teach our children well. The only protection that has a chance of working is giving young people moral grounding and common sense.

Thus, the communications revolution is going to force parents and society to communicate to its younger members. Yes, parents will have to talk to their children. Several months ago, I got an Internet account for my nephew who is seven. I didn't turn him loose until I filled him in on some facts of online life. "Just because someone sends you e-mail, you don't have to answer unless you know them," I instructed him. "And if anybody says something to you that makes you feel funny about answering, then don't answer until you speak to me."

147 ◄

Citizens should have the right to restrict the flow of information into their own homes. You should be able to exclude from your home any subject matter that you don't want your children to see. But sooner or later, children will be exposed to everything we have shielded them from, and the only resource they will have to deal with these shocking sights and sounds is the moral fiber we helped them cultivate.

Children need to be taught to have no fear of rejecting images or communications that repel or frighten them. They need to be taught to have a strong sense of their own personal boundaries and of their right to defend those boundaries. They also need to be taught that people aren't always what they present themselves to be and that predators do exist. Finally, they need to be taught to keep personal information

private. Yes, pedophiles and pornographers use computer networks. And although it is clearly illegal to use the mail for sending "obscene" material, pedophiles and pornographers still do—and nobody would argue that we need to censor these forms of communication.

The most relevant question now is: how do we teach our children to live in an uncensorable world? As Barry said, "I am an artist, but I don't want my four-year-old kid seeing some of the Mapplethorpe pictures. . . ." Undeniably, children must be shielded. Exposure to the wrong information at the wrong time really can hurt them. As James Coates writes, "I watched it hurt my own kids back in the 1970s before an angry public made the cable operators postpone their R-rated bodice busters until mommy and daddy got home from work. As the move to force cable operators to act responsibly illustrates, we take all kinds of steps to shield our children from the likes of smut magazines, *Showtime After Dark*, and, now, cyberporn."

James Coates continues:

> I just wish that the sexually charged filth was the worst of it. But it isn't. The Internet is full of stuff that shouldn't be there. It can be a cyber-sewer, seething with racist, demented, mindlessly violent stuff, some of it brought into your homes thanks to generous federal subsidies. The hatred, malice, and stupidity that abounds online, can do at least as much damage to your children's psyches as can the most hardcore downloadable pornography. Think about how a kid is going to be traumatized looking at full frontal photos of aroused nude men like ones I recently downloaded on America Online, using that service's new file grabber feature. But then think about something even worse. Think about what's going to happen when an African-American child finds his or her way to the "70 offensive jokes" file. That child is going to be confronted with the most vile, epithet-laden language imaginable. And that is unforgivable. Do you want your kids downloading anti-Semitic literature from the "cyberhate" site on the World Wide Web? Right now, the top offering there is racist J. B. Stoner's 1994 address to the Aryan Nations at an Idaho cross-burning.

I believe that technology, which made it possible for anyone to access anything on the Internet, will come to the aid of parents and educators.

. .

On July 2, 1995, the Senate passed a bill drafted by Senator James Exon to fine anyone who put indecent material on the Internet the sum of $150,000. In the House, Representative Ron Wyden (D-Oregon) drafted a counterproposal to Exon's bill that would make available to schools and parents, numerous technological tools that can be used to keep children from reaching the sordid places.

CENSORSHIP TOOLS

With more and more children using personal computers for education or fun, it becomes more and more important that management tools, such as the ones described below, be used to help monitor and control a child's use of their PC. These tools are needed not only to monitor and control access to online services and the ever popular Internet, but also to monitor, track, and control a child's use of other applications—such as computer games or online service applications. These management tools focus a child's use of his or her PC towards productive goals. Without such management tools, the child could be exposed to inappropriate material, or the child could spend an excessive amount of time in a game or an online service that charges by the hour.

There are various tools on the market that can be used to limit access to the Internet. Commercial software packages that promise relief are also reaching the marketplace. Carrying names such as CyberPatrol, CYBERsitter, NetNanny, and SurfWatch, these programs monitor keyboards and let parents shut off sites and language they deem inappropriate. Most of this software is just reaching the market.

- **CyberPatrol** This software allows parents to manage computer use in their own household by providing control over Internet access, use of local applications, and the times of day and total time in a day that children are allowed to use the computer. Cumulative duration of Internet and other application use is captured, allowing daily, weekly, and monthly reporting. In addition to providing a useful overview of computer usage, these reports can also be used as independent verification of an online service provider and telephone bills. CyberPatrol for Windows blocks access from any computer that uses WINSOCK-compliant Internet applications such as Netscape, America Online, Mosaic, or CompuServe to access the Internet. CyberPatrol for Macintosh

intercepts calls to the Macintosh TCP driver. CyberPatrol is the first and only Internet filter that works with all browsers, including 32-bit browsers such as Microsoft's *Explorer.*

CyberPatrol loads during start-up, and runs in the background, controlling access to all associated applications. CyberPatrol is accessed with a password and offers two levels of parental password control: Headquarters, the master password, which establishes parameters for Internet and application access; and Deputy, a password which allows an authorized guardian to bypass restrictions. The Deputy password automatically resets at midnight, disabling "Deputy" access. CyberPatrol blocks access to WWW, FTP, and Gopher, by site name (down to the file directory or page); UseNet, by newsgroup name (including a wildcard "*" extension); and Internet Relay Chat (IRC), by both name and identified words/phrases. Executable files on PCs, such as the programs for the major online services and games, can be blocked by both time of day and cumulative duration.

▶ 150

Several safeguards are included in CyberPatrol, including controls which prevent children from disabling CyberPatrol or simply renaming blocked applications. CyberPatrol 2.10 includes built-in support for the SafeSurf system. This gives parents and teachers even more control over the sites their children can access. CyberPatrol for Windows LANs provides centralized administration of the CyberNOT List, parental preferences; and time management settings. CyberPatrol Home Edition provides home users with basic Internet filtering, free of charge. It does not include parental preferences or time management functions.

- **The CyberNOT Block List** This is a listing of researched Internet sites containing material which parents may find questionable. Using the CyberNOT List, parents can reinforce their own personal values as they adjust children's access to specific Internet sites. The list is divided into categories, and access can be managed down to the file directory or page level. This means that appropriate material at an Internet IP address need not be blocked due to the presence of restricted material elsewhere at the address. Parents and teachers may select all or any of the categories to be blocked by general content, time of day, or specific Internet site. Parents

can select the categories of content that they wish to block, and can allow access to any site on the CyberNOT List which they deem appropriate. Parents can also deny access to additional sites not included on the CyberNOT List and can control/block access to the major online services as well as other defined applications such as games.

The CyberNOT List is updated weekly and can be automatically downloaded via the CyberPatrol software. Microsystems, Inc., the company that created CyberNOT List, encourages parents to report sites for addition to the CyberNOT List. All reported sites are researched thoroughly before they are included on the list. List price for CyberPatrol is $49.95, which includes a six-month subscription to the CyberNOT Block List. Subsequent six-month subscriptions are $19.95 each. Parents can download a full-feature demo copy, which will operate for seven days, and can easily register the software online when they decide to purchase it. CyberPatrol Home Edition is available free of charge at *cyberinf@microsys.com*.

In addition to CyberPatrol and the CyberNOT List, there are a variety of other censorship resources including:

- **SafeSurf** An organization working to make Internet access safe for young people. It is developing an Internet rating system.
- **CYBERsitter** A program allowing parents to block access to undesirable sites and to record sites accessed. It can be updated regularly without subscription.
- **NetNanny** A program to control access by children. NetNanny approaches the problem head-on with a keyword-driven product, which simply bars access when pre-programmed words or phrases are entered at the keyboard. The system can refuse access or even close down an application when it detects barred words.
- **Internet Filter Software** Designed for educational institutions. It is used to block access as required.
- **WebTrack™** An Internet control and monitoring software designed to allow business to control access to web sites by staff.
- **Surfnet** Blocks Internet pornography. It will allow parents and educators to block unwanted material locally.

- **NetGuardian**[℠] From New*View, Inc. allows users to control Internet access by children and employees.

Some say that no stand-alone software is going to solve the problem, that censorship tools need to be built into the way the net works. The "v-chip" for television sets, for example, relies on a rating system. Programs that are rated too violent, can be automatically blocked, on a household by household basis, by the v-chip.

SurfWatch was the first commercial software giving parents Internet censorship power. When it was released, the objection heard most often was that parents feared that their children knew far more about computers than they did. Even relatively simple software, like SurfWatch, is sometimes considered too difficult for some parents. The answer to that is: parents really don't have a choice. Parents had better learn how to operate this simple software before leaving it to the government to set up a censorship police force. It is the responsibility of parents to do their best to understand the world their children inhabit. Parents should learn something about where their children spend their time, and that includes the cyberspaces they are exploring while they are sitting in their rooms alone.

▶ 152

HOME-GROWN SOLUTIONS

Many computers sold today for home use include modems and free memberships with online services such as CompuServe and America Online. Most parents want their child to get the most out of his or her computer experience. When connected to the Internet or an online service, or when running a compelling computer game, a child can become fixated as he or she seeks out online information. This activity can quickly replace hours of TV viewing. Many parents were initially pleased when their child no longer spent hours staring at the TV and instead stretched their creativity and expanded their computer skills. Thus, it was easy to just let a child roam freely through these online services, the Internet, and computer games. However, just as a parent monitors and limits a child's viewing of the TV, the parent should not come to trust online services to provide only suitable material for the child or trust that the child will not spend excessive time in one game or stay in a charge-by-the-hour online service.

There are several ways one can help monitor and control how a child uses his or her PC. These activities will help keep the child focused on educational and fun activities. Among these are: creating ground rules, encouraging constant dialog, monitoring a child's online habits, and using tools to control a child's PC access. If censorship laws are not the answer, the question of easy access by children to objectionable material online will remain a concern to parents, librarians, and teachers. But there is a crucial difference between controlling what children or students see and hear, and giving that control to an agency of the government. Despite the political tactics of would-be censors, speaking up for the rights of families and schools to make their own decisions is not the same thing as advocating pornography for children.

RATINGS

An agreed-upon ratings system would allow individual households and institutions to decide exactly how to set their own censorship filters. I support what I like to call "self-rating systems." This system puts the burden of rating on the developer of web sites. Artists and other groups should come up with a system of ratings. When a web site is developed, it would be given a rating. This rating, like a movie rating, could be used to limit access. This approach would put the issue of censorship back to the Internet community, which has a long and proven history of using netiquette to solve problems.

153 ◄

The rush to make ignorant and ultimately harmful laws, fueled by phony research, such as the discredited *Rimm Study* of pornography on the Internet, is senseless. We already have tools for solving this problem at the level where it ought to be solved, the family and community. There are several excellent proposals for technical measures that would give parents, teachers, and librarians control over how children access objectionable material. These tools make the parent, teacher, and librarian, not the state or federal government, the arbiter of objectionable and acceptable material. As Howard Rheingold says, "While ambitious politicians, using bogus research, brandish the image of porn-shocked children to cover for their own naked power-grab, some of the most important institutions in the nascent online industry are actually doing something about parental control of children's Internet access." Three of the biggest and most influential computer network companies,

Progressive Networks, Microsoft, and Netscape Communications, have formed the Information Highway Parental Empowerment Group. They worked to complete a report about parental information-blocking software. This working group is acting quickly to build the tools for censoring content at the local level. There is no question that censorship will come to cyberspace soon. The important question now is whether it will be done through citizen-operated tools or through state-imposed rules.

COPYRIGHT

T he protection of copyright and intellectual property on the Internet will be one of the most important and hotly contested issues of the new millennium. This strikes at the core of our entire current economic system, which is based on the ownership of property and remuneration for the use of that property.

ONE STEP AT A TIME

Every time I have given a talk to artists, the question "How will my art be protected on the Internet?" invariably pops up. The simplest way to protect intellectual property and copyright on the Internet is to include a copyright infringement notice with the data, as is done with books. This notice might read:

This data is copyrighted—for holders of copyright, see individual records. The data is made available for the purposes of research, environmental information, and educational activities. Any use of the data for other purposes, including for all commercially related activities,

requires permission of the individual data custodians. Any use of the data must acknowledge the holder of copyright as data custodian.

This notice obviously won't prohibit someone from infringing the copyright; however it does provide a recourse through the courts if necessary and makes users aware that the data is copyrighted. Unfortunately, such a notice generally won't dissuade the dishonest user.

Is there a way to protect the artist and the creator or producer of information and intellectual property? Ever since I have been on the Internet I have been perplexed by the conundrum of digitized property. The problem is this: if digitized property can be reproduced and distributed all over the planet without cost, without our knowledge, without its even leaving our possession, how can we protect it? How are we going to get paid for the work we do with our minds? And, if we can't get paid, what will assure the continued creation and distribution of such work?

As John Barlow states:

▶ 156

> Since we don't have a solution to what is a profoundly new kind of challenge, and are apparently unable to delay the galloping digitization of everything not obstinately physical, we are sailing into the future on a sinking ship. This vessel, the accumulated canon of copyright and patent law, was developed to convey forms and methods of expression entirely different from the vaporous cargo it is now being asked to carry. It is leaking as much from within as from without.

THE REAL ISSUE

The creation of multimedia content and digital libraries raises profound issues with regard to notions of copyright and intellectual property. John Barlow remarks that,

> . . . notions of property, value, ownership, and the nature of wealth itself are changing more fundamentally than at any time since the Sumerians first poked cuneiform into wet clay and called it stored grain. Only a very few people are aware of the enormity of this shift, and fewer of them are lawyers or public officials. Those who do see these changes must

prepare responses for the legal and social confusion that will erupt as efforts to protect new forms of property with old methods become more obviously futile, and, as a consequence, more adamant.

Can property ownership and freedom of communication as vast as the Internet provides commingle? This is the real issue. Many anti-properterians take the position that since shared information still resides with its creator long after it has been passed along, trying to treat information as an object is a flawed approach. Creativity, they argue, does not depend on a government-granted monopoly. "Consulting, support, performance, and service—these are all ways in which creators can make money of their abilities without appealing to intellectual property rights," reads one private citizen's recent posting on a UseNet newsgroup. "Removing such rights would not deny creators the right to profit from their labors; it would, however, allow all of society to share in the benefits of their work."

The other issue is that information is, by nature, intangible and hard to define. Like other such deep phenomena as light or matter, it is a natural host to paradox. Copyright expert Pamela Samuelson, a lawyer, tells of having attended a conference last year convened around the fact that Western countries may legally appropriate the music, designs, and biomedical lore of aboriginal people without compensation to their tribes of origin, since those tribes are not "authors" or "inventors."

157 ◄

"But soon most information will be generated collaboratively by the cyber-tribal hunter-gatherers of cyberspace," John Barlow says, "and perhaps our arrogant legal dismissal of the rights of 'primitives' will be soon return to haunt us."

FOUR VIEWS

Before we can develop any new methods to resolve the core issue, it is important to understand the landscape of cyberspace and how Internet users deal with this issue today. First, cyberspace has no national or local boundaries to contain the scene of a crime and to determine the method of its prosecution; worse, no clear cultural agreements define what a crime might be. Basic unresolved differences between Western and Asian cultural assumptions about intellectual property can only be exacerbated

when many transactions are taking place in both hemispheres yet, somehow, in neither. Views on this issue, as expressed by users of the Internet, appear to fall into four groups:

A. **Information Wants to be Free** These people believe there should be no copyrights or other protections of intellectual property; everything made publicly available should be public domain.

B. **Right Attribution** These people believe that the only rights owed to authors and creators is the right of attribution; otherwise, all information is free.

C. **Limited Use Rights** These people believe that copyright has validity, but minor infringing behavior, whether "fair use" or not, should be legal.

D. **Strong IP Regimes** These people adhere strictly to intellectual property protections.

As Lance Rose has pointed out, no one segment dominates the other; rather, we can expect that each segment will continue to attract adherents well into the future. The issue then becomes whether copyright laws should be extended to override the beliefs of people in categories A and B, or if we want to conform primarily to the behavior of people in categories C and D.

HOW TO PROTECT YOUR PROPERTY

There are five ways of protecting property in cyberspace to varying degrees.

The first way is what I call *full protection*. Full protection is simple: Just don't put your property on the Internet.

The second way to protect property is by using the copyright statement shown above. This will serve as a deterrent but is not 100 percent guaranteed.

The third way to protect property is by using the power of the Internet community. Until the American West was fully settled and "civilized" in this century, order was established according to an unwritten code, which had the fluidity of common law, rather than the rigidity of statutes. Ethics were more important than laws. Understandings were preferred over laws, which were, in any event, largely unenforceable. There is a strong tradition on the Internet to develop user norms and practices in

an almost ad hoc, yet slightly anarchistic, fashion. *Fair use* norms on the Internet include forwarding e-mail messages, or a portion thereof; quoting portions of UseNet and mailing list postings; and making private non-commercial copies of texts downloaded from FTP, Gopher, or web sites. In most instances, Internet denizens adhere to rules of netiquette and common-sense practices which do not violate acceptable net practices. Flagrant disregard for net rules can result in net "community-policing" and admonishments by fellow "netters" to follow ethical practices.

Internet culture abides by netiquette which may itself serve to keep the violator of copyright in check. If someone submits a infringing posting to a newsgroup, for example, the Internet's response is egalitarian and swift: the poster may be publicly flamed, privately chastised, or even added to the user's "bozo filter," and henceforth blocked from that user. These norms of netiquette can also be used as a deterrence from intellectual property violations. Stealing someone's artwork or image from a web site, for example, may also be subject to the Internet's rebuke. If a conscious citizen on the Internet sees a piece of stolen property appearing on another web site, they can either notify the offender and the victim, or both. Note that as the Internet population has exploded, this trait of self-policing and netiquette has not yet abated. Rather, it appears to have remained an integral part of the socialization process of the Internet.

The fourth way to protect property is through advanced technological solutions. One method uses strong cryptographic algorithms. This method gives an electronic publisher even stronger control than that exercised by most traditional publishers. The use of encryption technology, will allow for copyright statements to be encrypted into the document and thus be transferred with the document wherever it goes. The prodigious Ted Nelson, who coined the term *hypertext* in 1964 and conceived of Project Xanadu (a virtual repository for the textual, visual, and auditory artifacts of civilization), has formulated a novel approach to the copyright problem. In his Public Access Xanadu (PAX) system (originally scheduled to be test-marketed in 1993 and franchised in 1996), documents are encoded with accounting software, which tally royalty payments and bill patrons' accounts accordingly. Royalty fees will buy fair use privileges for the documents or portions thereof, and the

patrons' monthly bills include connect time, storage and transmission charges, and publication fees, crediting royalties from others for work read online—basically a pay-by-the-byte system. Other systems like this one are now in use online.

The fifth way of protecting property on the Internet is to either craft new laws or bolster existing ones. This was the approach taken in the Green Paper on "Intellectual Property and the National Information Infrastructure," which was released by the Working Group on Intellectual Property Rights in July 1994. The paper recommended that the Copyright Act of 1976 be amended slightly to accommodate the advent of digital information. Specifically, the paper recommended that: 1. digital transmission of a copy of a copyrighted work be considered an act of copyright infringement; 2. "first sale" rules for works transmitted digitally be abolished; and 3. copyright infringement could be construed if technological devices are used to circumvent copy-protection schemes that copyright owners have created. Legislation is now being developed based on the Green Paper.

▶ 160

For those interested in learning other ways of protection, Tad Crawford, lawyer and publisher, has written the *Writer's Legal Guide* (Allworth Press). This guide offers both historical and practical information on dealing with the issue of copyright. The guide also addresses how to protect all types of multimedia work including text, graphics. and audio.

COPYRIGHT OF HYPERLINKS?

How will copyright be adjudicated and managed for hypertexted links? The explosion of WWW servers and the increase in WWW traffic (now the fastest growing part of the Internet, with an exponential increase in registered servers over the last eighteen months) poses new intellectual property questions. Some say that these hypertexted links create a "value-added service" to the main document containing the links. The question is: will the author of the link document want compensation when someone traverses his or her own links? Does the author of a link document infringe copyrights in the works to which links have been created, as unauthorized derivative works? Does a user of someone else's links infringe any copyright interest of the link author?

Authors of hypertext links would, of course, like to be free from

claims of infringement for linking portions of other authors' documents, yet be able to assert copyright control over traversals of their links by other users. Obviously, an issue such as this one can get quite tricky. The issue, moreover, exemplifies the kinds of complexities that the WWW introduces in terms of copyright law.

USING COPYRIGHTED MATERIAL

If you are going to use material on the Internet for which you do not own a copyright, then you must obtain permission from the copyright holders. This usually means contacting the copyright holder and obtaining written permission to use the material. This may sometimes incur a charge. For material subject to United States copyright law, the Online Copyright Clearance Center has been set up to help individuals obtain permissions, "ease permissions burdens, and consolidate payments for rightsholders."

OTHER PROBLEMS

The copyright scheme is not especially well-suited to assigning ownership interests when there is collective development. We have already seen this problem in multimedia, to which the copyright clearance process could provide some relief, but there remains the difficult issues arising from "message bases," digital sampling, and product produced by groupware. The creation of multimedia works will, in many instances, depend upon securing copyright in an economically feasible manner, while guaranteeing that creators are justly compensated for their works and that the moral integrity of their work is kept intact. The concept of copyright in the electronic environment is therefore legally challenging and socially provocative.

CULTURAL EFFECTS

What kind of culture will we have in the new world of cyberspace? For artists and those in the art world, this question is an important one. Art itself is being, and will continue to be affected by the growing cyberculture. In order to develop a cogent view of how the Internet will affect culture, various aspects of cyberspace need to be explored.

TELECOMMUTING

There is no doubt that the Internet and computers are giving way not only to a whole new way of communicating, but to a whole new way of living. Professor Stephen H. Crandall, a pioneer in theoretical mechanics at MIT, is in his mid-seventies and gave the Distinguished Lecture Series in November of 1995 at MIT. Reflecting on his life as a professor at MIT for nearly fifty years, he talked poignantly about how the world had changed since he first came to MIT in 1946, at the end of World War II. He said that in the 1950s, MIT would allow him only one day a week to make additional income from consulting. He would get up at 4:30 A.M. at his home in Lincoln, Massachusetts, drive to South Station in Boston, take the 6:00 A.M. train to Philadelphia, and arrive six hours later to do a full day of consulting. He would then take the midnight train

from Philadelphia back to Boston, arrive at 6:00 A.M. the next day, and take a cab to teach his 9:00 A.M. class at MIT.

As time went on, airplanes became a more feasible means of transportation, and he could leave his home at 6:00 A.M. and be back at his own house by midnight, where he could sleep in his own bed before heading to MIT for his 9:00 A.M. class. Today, Crandall went on to say, professors travel by plane more than he ever did and can do one or even two consulting gigs a day. He ended his talk, however, by predicting that in the future the communications revolution would obviate the need for lots of travel since there would be more telecommuting.

Why travel if you can speak, show documents and pictures, and see live video of someone thousands of miles away without jet lag or lost baggage? Telecommuting will become more prevalent as we move into the future. It will become a day-to-day reality for many of us. How, exactly, this will affect culture is not yet known. No doubt, people will become more well "traveled." But how rich and real will their experiences be?

▶ 164 TECHNO-GENERATION GAP

The biggest cultural differences will arise not so much from black and white, from rich and poor, or even from the young and the old, but from those who learn technology and those who don't. Young people are growing up with electronic communication and interactive media. My seven-year old nephew, who loves to paint and break dance, knows how to get on to the Internet, use CD-ROMs, play video games, and program computers far better than his mother. He loves art and the Internet. For him, there are no issues of technophobia, or contradictions in doing art and being on the Internet.

Unlike many other professionals, artists have a history of taking advantage of new technologies, either to create new art forms or to enhance existing ones. Paints and resins are tools that result from research and development by chemists. Lathes, drills, and other mechanical equipment are the creation of both machinists and mechanical engineers. Performing artists such as musicians, dancers, and actors use microphones, lighting, amplifiers, and an assortment of electrical tools to create live performances. The computer and the Internet are just additional tools which artists can use for communicating or for producing art itself.

A friend of mine is a sculptor. His studio transports you back to the sixteenth century. Even so, he uses a Macintosh computer and the Internet as communication tools. He uses the technology for doing word processing, maintaining a database of his clients, creating promotional brochures, and communicating with potential clients and artists over the Internet via e-mail and the WWW. His computer extends his reach. He has developed a community of artists around the world whom he communicates with regularly. He maintains his sixteenth-century studio while using twenty-first century technology to build a global community of artists.

Innovative artists, galleries, and museums, as mentioned above, are also beginning to explore collaborative art and performance art on the WWW. Artists are breaking the techno-generation gap by using the computer to create such collaborative art pieces. Some arts supporters question the originality of such art because sometimes computer-generated art is categorized as photography. When it comes to using the computer to create art, there will be some temporary divisions, however, as the tools for creating art begin to emulate the human form, more artists will find clever ways of integrating the computer and interactive technologies.

"LIVE" PROGRAMS

David Brown, the general manager of Boston Ballet, has a "Jekyll and Hyde" relationship with the interactive media, the Internet, and cyberculture. He says he loves it and he despises it. He loves using the Internet as a marketing tool, an information resource, and a communications medium. He despises it because he believes that it has the potential to put live entertainment out of business.

In the current culture, Brown points out, entertainment has become individualized. In many homes there are a minimum of two TVs. Even when it comes to TV, families no longer gather to watch one TV program together. The parents may watch one program on one TV, while the kids watch another. People listen to their CDs with headphones, on portable CD players, while running in the park. One person in a household may watch a movie on the VCR while another plays their favorite game on the computer.

The cultural issue is whether interactive media will destroy live

performances. For example, it is far easier to stick a CD into a CD player than to attend a live performance at a symphony hall. Attending a live performance demands that the viewer deal with more-physical things, such as finding a place to park, making dinner reservations, ordering tickets, picking up the tickets, showing up on time, and the like. Why would anyone want to go to a live performance if they can get the sounds and scenes in the comfort of their own living room with high-definition TV and Dolby surround sound? This question turns David Brown into Mr. Hyde. He sees a real threat to live entertainment.

However, as Dr. Jekyll, Brown also sees the potential the Internet and interactive media offers in terms of actually supporting live entertainment and increasing audience attendance. Using technology effectively, attending a live event can be made far easier. Ticket, parking, and dinner reservations can all be done from home via the Internet. Moreover, the Boston Ballet could use its web site to educate the public on the athletic skill that is necessary for a ballet dancer to leap fifteen feet in the air. The textual description of ballets, along with audio and video previews, can be used to further educate and entice prospective customers.

Effectively used, I believe that technology can increase attendance to live performances. I don't believe that people simply want to stay online all of the time. Regardless of how many times I listen to Bruce Springsteen CDs, I still want to see him live. Online, or interactive activity, can be used to fuel off-line events and happenings.

Information online can be used as a vehicle to encourage off-line activity. In an age of web sites and the Internet, it becomes essential for those running live-entertainment organizations like the Boston Ballet to study the Internet and its tools for online promotion. This obviously places new pressures on those in live entertainment. Internet tools such as the WWW can be cleverly used to *infotain* and to inspire potential audiences online to attend a live performance off-line. Thus, in many ways, those in live entertainment have no choice but to learn how to use this powerful medium for garnering new clientele.

GOOD ART VS. BAD ART

Many in the arts are concerned about the quality of art on the Internet. Some wonder whether an uneducated public will know the difference between good art and bad art. What is of concern is that the

ability to access any of millions of bits of information with equal ease, may lead one think that all information is equal. I am obviously not in support of censorship; however, I do think we must consider how a young child knows the difference between van Gogh's *Starry Night* and a child's sketch of her backyard? If one cannot differentiate between these, our intellectual and cultural future is grim.

I believe that if an Internet viewer cannot understand the difference between *Starry Night* and an eight-year-old's Crayola drawing, that is the not a problem of the Internet; that is a problem of education. If anything, the Internet can be used to self-educate the viewer on the difference between the two pieces. What does this mean? This means that artists and those placing their artwork on the Internet need to make changes, not the Internet viewer. Artists need to make a cultural shift. Artists will have to come out of their closets and will need to learn how to interact and communicate their art to a Internet viewership, which is fundamentally curious and intelligent. Art, after all, is about the artist and the exploration of self. Those on the Internet like to probe and explore. Displaying a piece of art, therefore, can become a joint **167** ◄ exploration between artist and viewer.

THE END OF IMAGINATION?

Paul Sacksman, publisher of Billboard Publications' *Musician* magazine, recently told me a story. A friend told him that he had "visited Alcatraz using a CD-ROM program and that it was awesome." Sacksman said, "You didn't visit Alcatraz, man!" He asked, "Did you smell anything? Did you feel the vibes around you?" His friend answered no to each of these questions.

It is Paul Sacksman's belief that cyberculture may affect our ability to imagine. He argues that many in cyberculture are starting to think that the future is here. He thinks that many have gotten so technocentric that they believe that anything can be created. So, he asks, where is there room for imagination? It is a valid question.

Even Nicholas Negroponte, the author of *Being Digital* and the co-founder of the MIT Media Laboratory, states in the introduction to *Being Digital* that he chose to write a book "without any pictures or diagrams" because he wanted "to excite the reader's imagination." Such a statement tends to support Paul Sacksman's view.

The proliferation of technology is affecting our definition of reality. Interactive media cannot replace the human sensual and extrasensory experiences. Some, however, argue that one day human beings and machines may merge. What will we become then?

INTERNATIONALISM

While the Internet may result in some cultural loss, the Internet will greatly bolster other aspects of culture. Some point to the de facto standard of using the English language on the Internet as a trend towards loss of cultural identity for non-English cultures. On the other hand, the ability for members of national, cultural, or religious groups, separated by emigration or war, to keep in contact with one another via the Internet and WWW is one beneficial point for maintaining cultural continuity. Furthermore, I believe that new technologies such as cross-language translators may enable people to maintain cultural identity by allowing them to speak their native language and have it automatically translated into other languages.

▶ 168

Users can already talk in real-time to people from around the world, and many are beginning to discover what it's like to think in a foreign language and live in a foreign country. Internet Relay Chat (IRC), for example, is fun and educational for this very reason. IRC users can learn more in simple conversations than they ever would in years of history and geography.

Instead of getting news from filtered media sources, users can now find out the real story from people who are actually there. This feature of the Internet has already had tremendous impact on political developments in nations where media coverage is limited. This free and open sharing of information will have the most significant cultural effect on all aspects of life: political, social, and economic.

EPILOGUE

GRAND FUSION

Art is always and everywhere the secret confession and, at the same time, the immortal movement of its time. Karl Marx, 1859

In physics, *fission* and *fusion* are very different concepts. Both release energy; however, fusion releases millions of times more energy than fission. Fission is the result of *splitting* atoms. Fusion is the result of *uniting* atoms.

In the 1940s, scientists applied fission. They learned how to split the atom and created the atom bomb (A-bomb) for mass destruction. The development of the A-bomb led to the cold war, which led to greater splits in the human race. As spiritual masters say, "as above, so below." At the micro-level, we split the atom. At the macro-level, we split ourselves, and the cold war raged on from the 1940s to the late 1980s.

In the 1960s, with great irony, the Internet was developed as a way to protect communications of the United States government in the event of an atomic bomb attack on the Pentagon. The Internet was created by the same United States Department of Defense which funded the splitting

of the atom and the fueled the cold war. By the 1990s, the Internet was available to almost every citizen of the world.

Fusion creates more energy than fission. When two atoms are brought together, millions of times more energy is released. The Internet brings people together. It is enabling diverse groups of people to connect and make relationships as never before. The Internet is collapsing time and space, enabling such fusion to take place.

Art, science, and technology have been increasingly divided for millennia. With the Internet, both artists and technologists will benefit. Art and technology, and other aspects of human life, will once again begin to merge. However, this union is not going to occur spontaneously. No revolution simply occurs. Revolution is a conscious undertaking. As artists and members of the art world, you must step consciously into this revolution. Society has much to gain by the grand fusion of art and technology. The ability to make connections will open new doors of discovery for both artists and scientists.

A few weeks before Christmas, 1995, there was an article in the *New York Times* entitled "Cardiologist Answers a Raphael Question." For over five hundred years, artists, art critics, art historians, and scholars were baffled by a painting known as the *Transfiguration*—a huge altarpiece hanging in the main picture gallery of the Vatican Museum in Rome, by the Renaissance painter, Raphael. In this painting, Raphael had coupled two scenes from the Bible. Apparently, no previous artist had coupled these two biblical scenes in one painting. The top of the painting was the scene of Christ rising from Mount Tabor in glorious triumph. The bottom part of the same painting was another biblical scene, showing the failure of Christ's disciples to cure an epileptic boy. Why did Raphael place these two scenes together?

In 1961, I.S.J. Freedberg called the two scenes "irremediably disconnected" and "peculiar." In 1971, Sir Pope-Hennessy, wrote of "two unrelated scenes." A British art authority, E. H. Gombrich, characterized the pairing of scenes as perplexing and "untenable."

Dr. Gordon Bendersky, a cardiologist and art lover, after careful examination of the painting, noticed something that everyone had missed. Based on his scientific knowledge of epilepsy, he realized that the boy in the bottom painting was actually in a *post-ictal* phase of the epileptic attack. The post-ictal phase occurs at the end of an epileptic

. .

attack, when the individual is standing up, eyes rolled back, and hands stretched back, and that was the position of the boy in Raphael's painting. So, the painting showed that the boy had actually been healed by the disciples.

The *Transfiguration* by Raphael, according to Dr. Bendersky, was therefore not really a painting of two unrelated scenes, as many experts had thought. He concluded that the "two scenes were bound together by showing mutually compatible scenes of the divinity of Christ and His miraculous power to heal." His discovery was hailed by the art world, for whom these two scenes had been a mystery for over five hundred years.

In the sixteenth century, during the Renaissance and the time of Raphael, scientists and artists collaborated. Most artists, as Bendersky said, were familiar with medical knowledge and the intricacies of diseases like epilepsy, which were quite common. There were fewer divisions between art and science. That is what made the Renaissance a glorious time in human history.

Today, the Internet—a product of the cold war—is bringing us together. I am confident that it will be stage for artists and scientists to meet once again. Such a stage may help in solving many other mysteries of both art and science, and may serve to bring about a new Renaissance for humankind.

APPENDIX

GLOSSARY of TERMS

Agents Software programs that automatically execute prescribed tasks, 177 ◄ based on personal or static information.

America Online (AOL) A private online network service that is separate from the Internet, but offers users access to the Internet.

American Standard Code for Information Interchange (ASCII) A protocol for pure text.

Anonymous A user login name used to get access to most FTP sites.

Archie A UNIX program for finding files on the Internet.

ARPANET Advanced Research Project Agency's Network; the network created by the United States Department of Defense Advanced Research Project (DARPA); the network from which the Internet arose.

Asynchronous An event that is time-independent.

Asynchronous Transfer Mode (ATM) A cutting-edge protocol for transmitting

data at very fast speeds. ATM is probably the only protocol that will enable entire movies to be transported over wires.

AVI A file format for storing compressed movies.

Bandwidth The amount of information that can be transmitted through a communications channel at one time (seconds).

Baud The number of bits per second of communication over phone lines.

Browser A program that lets you access files and the content of files, and also provides for navigation between files.

Bulletin Board (BBS) An older system that allows users to call, and interact with, each other. Similar to the Internet, but on much smaller scale.

C, C++ Computer languages used to develop computer software.

Cache The act of storing a remote document locally, to increase access speed on repeated requests.

CD-ROM An information storage medium for storing large volumes of information from 640 megabytes (MB) to 1.2 gigabytes (GB).

Central Processing Unit (CPU) The brains of a computer.

CERN The European Particle Physics Laboratory in Geneva, Switzerland. The group that invented the World Wide Web (WWW).

CERT The Computer Emergency Response Team whom you should report security breaches to.

Cgi-Bin Custom programs that may be used to extend the web and make it interactive.

Client Sometimes used to refer to a browser and at other times a computer contacting to a server or host.

Clip Art Ready-made artwork; useful in creating web pages.

Computer Professionals for Social Responsibility (CPSR) An organization concerned with the ethical use of computers.

Cracker Someone who breaks into computer systems.

Crawler A program that moves along the web looking for URLs or other information; a type of intelligent agent.

Cyberpublicity The promotion of a web site address to other sites, directories, newsgroups, and the like to increase qualified traffic to the web site being cyberpublicized.

Cyberspace A term for immersible virtual reality; sometimes used to denote the Internet.

Database A collection of organized searchable data.

179 ◀

Decryption The act of making a secure file readable.

Digital Signature A secure mechanism to verify the identity of an individual.

Domain Name The name of a computer system on the Internet. Each computer system has a unique domain name.

Domain Name Server (DNS) A system that resolves an Internet Protocol (IP) address to a domain name.

Element A basic HTML command such as <title> indicates the beginning of a title.

Electronic Frontier Foundation An organization of people concerned about the legal rights of computer users. Most current laws do not specifically apply to electronic communications.

Electronic Mail (e-mail) Personal messages sent between users of the Internet.

Encryption The method of making a readable file secure.

Eudora The most widely used e-mail program on the Internet. It is easy to use and runs on multiple platforms.

File Transfer Protocol (FTP) Software that transfers files to and from remote computers.

Finger A program that identifies a user.

Firewall A security measure that helps to limit pirate attacks.

Flaming An expression of displeasure at another user.

Frequently Asked Questions (FAQs) A list of helpful suggestions and answers to questions on various topics.

Gopher A menu oriented FTP-type program that does not allow the use of pictures, links, or other advanced WWW features.

Graphic Interchange Format (GIF) A file format for images developed by CompuServe.

Graphical User Interface (GUI) A graphical system for interaction with the screen using at least the mouse and the keyboard.

Hacker Someone who is good at computers. A computer guru.

Home Page The first page of any web site on the Internet WWW.

Host A computer system that maybe contacted by other computer systems.

Hot List A list of a user's favorite sites on the web.

HyperText Markup Language (HTML) The language of the WWW which formats documents to look presentable. HTML is a subset of Standard Generalized Markup Language (SGML).

HyperText Transport Protocol (HTTP) The protocol for the WWW which allows text, image, audio, and video to be combined into a single document. HTTP also allows the linking of documents and document components.

HyperText Transfer Protocol Daemon (HTTPD) The WWW server software responsible for handling WWW requests.

Hyperlink An HTML element that, when clicked, allows people to move to other documents, images, sounds, movies, or other elements.

Hypertext The method of organizing documents, collecting documents or components of documents for navigation.

Icon A small image representing a function or action. For example, a small picture of a stop sign to indicate the way to stop a program.

Inline Image An image appearing to be apart from the document it is with.

Integrated Services Digital Network (ISDN) A technology that offers six times the performance of the fastest modems, and beyond. ISDN can be used by both individuals and corporations.

Intelligent Agent A program that performs intelligent functions automatically without manual user input. It can search for information, deliver information, or respond to information.

Interactive A method of allowing users to change the course of events based on their own decisions with regard to the rules of whatever they are interacting with.

Internet The term for the worldwide network of computers and users.

Internet Network Information Center (InterNIC) The organization which, through the National Science Foundation (NSF) award, is responsible for providing information to the public about the Internet.

Internet Protocol (IP) A method for handling the actual transmission of data over the Internet.

Internet Protocol Address (IP Address) A numerical address composed of four elements that uniquely identify a computer on the network.

Internet Relay Chat (IRC) A real-time talk forum.

Internet Society (ISOC) An organization that seeks to encourage the use and evolution of the Internet, and provides educational materials for, and a forum for discussion on the Internet.

JPEG A file format for compressed images.

Lag The amount of time in between actions.

Listserver A program that automatically dispatches outgoing e-mail based on incoming e-mail.

Local Area Network (LAN) Local networks consisting of a few computers networked together.

Login The act of accessing a remote computer.

Login Name A word or series of characters used needed along with a password to enter into a computer system.

Multipurpose Internet Mail Extensions (MIME) An Internet standard for transmitting audio, video, or still images by e-mail.

MILNET The original part of the ARPANET currently used by the military. It was renamed when ARPANET split.

Modem Refers to modulator-demodulator. A piece of hardware that connects to a computer. The modem enables digital communication to a computer network.

Mosaic The name of the original browser from the National Center for Supercomputing Applications (NCSA) for accessing the web. The first browser software for the WWW.

Mouse An input device used by one hand with choice entered by pushing buttons.

MPEG A file format used for compressed movies.

Multiple Platforms Refers to the variety of computers platforms such as PC, Macintosh, workstations, etc. A software program that runs on multiple platforms is preferred to one that runs just on one type of computer.

National Center for Supercomputing Applications (NCSA) The developers of the Mosaic software.

NetCruiser An integrated software program that offers a WWW browser, FTP, e-mail, IRC, and connection to the Internet.

Netiquette The unwritten rules of etiquette on the Internet.

NetNews A forum for Internet newsgroups where all messages written by users are displayed as a threaded list of messages.

Netscape The popular WWW browser that currently offers many cutting-edge HTML features.

Password A secret word or series of characters used to enter a computer system or software program.

Phracker Someone who breaks into phone and computer systems.

Phreak Someone who breaks into just phone systems.

Pirate A software pirate; someone who steals computer programs and usually sells or gives programs away.

Proxy A method for hiding databases by rerouting requests.

Public Domain Software or other materials to which no copyright is held or enforced, allowing free access and use.

Robot An automatic program that will go out and search for and retrieve information for the user.

Serial Line Interface Protocol or **Point-to-Point Protocol (SLIP/PPP)** Currently the quickest and most powerful method to access the Internet with a modem.

► 184 **Server** A software program or hardware that serves data.

Shareware Software that is openly available but is not free.

Snail Mail A term being used to refer to traditional mail systems such as the postal system, Federal Express, UPS, etc. Federal Express cannot, for example, guarantee delivery in less than sixty seconds.

Standard Generalized Markup Language (SGML) The original markup language defined by the United States government for organizing documents in hypertext format.

Subscription Services A web site that requires users to log in.

Surf To use the Internet and WWW.

System Operator (SYSOP) The system operator of a computer system responsible for the day-to-day operations.

T1 A physical connection that provides high-speed Internet connection that is more than a hundred times more powerful than a 14.4K modem connection.

T3 A physical connection that provides even more powerful connection than a *T1*. A T3 connection is twenty-eight T1 lines.

Telnet A software program that lets you log into remote computers.

Throughput The amount of data transmitted through the Internet for a given request.

Transmission Control Protocol/Internet Protocol (TCP/IP) The protocol for peer-to-peer communications and packet switching on the Internet.

Universal Resource Locator (URL) The means of identifying a home page on the web.

Viewer An adjunct program that handles non-standard data.

Virtual Something that exists only in an electronic medium such as a computer.

Virus A program that infects other programs and computers resulting in some sort of malfunctions.

Wide Area Information Server (WAIS) A distributed information retrieval system.

Warez Stolen software.

Warez site A place on a computer where stolen software can be found. Quite often placed surreptitiously on legitimate computer systems by pirates.

WAV Popular file format use for audio files.

World Wide Web (WWW) An organization of files on the Internet.

Wrapper A program that helps improve security by watching user's access systems.

LIST of WEB SITES

Age of Enlightenment in the Paintings of France's National Museums
 http://dmf.culture.fr/files/imaginary_exhibition.html

Age of King Charles V
 http://bnf.fr/eluminures/aaccueil.htm

American Arts Alliance
 http://www.tmn.com/Oh/Artswire/www/aaa/aaahome.html

American Council for the Arts
 http://199.222.60.120/

Andy Warhol Museum
 http://www.usaor.net/warhol/

Aaron Concert Management
 http://www.aaroncon.com

AfriNet
 http://www.afrinet.net

Allworth Press
http://www.arts-online.com/allworth/home.html

Alvin Ailey
http://www.alvinailey.org

Archive
http://jefferson.village.virginia.edu/rosetti/rosetti.html

Art 101 *(distance learning site)*
http://www.suu.edu/Museums_Galleries/artapp.html

Art Crimes *(images of graffiti by Susan Farrell and others)*
http://www.gatech.edu/desoto/graf/Index

@art gallery
http://gertrude.art.unic.edu/@art/gallery.html

Art History Resources on the Web
http://witcombe.bpcw.sbc.edu/ARTHLinks.html

Artswire *(from the New York Foundation for the Arts)*
http://www.tmn.com/Artswire/www.awfront.html

Artist's Index *(from World Wide Art Resources)*
http://www.concourse.com/wwar/artists1.html

Art Laboratory
http://www.artn.nwu.edu/index.html

Art Museum Information Worldwide
http://www.ircam.fr/divers/musees-art.html

Arts Network for Integrated Media Applications (ANIMA)
http://winsey.com/anima/ANIMAhome.html

Artscope
http://www.artscope.com

Artsource
http://www.uky.edu/Artsource/artsourcehome.html

Art on the Net
http:// da.awa.com/artnetweb/slidereg/slidereg.html

Arts Online *(the premier multi-arts cybervenue)*
http://www.arts-online.com

AusArts *(Australian Art)*
http://ausarts.anu.edu.au/ITA/AusArts/index.html

Bayeux Tapestry
http://www.blah.bsuvc.bsu.edu/bt

Blacksburg Virginia Electronic Village
http://www.bev.net

Body Missing *(by Vera Frankel and others)*
http://www.yorku.ca/Body Missing

Boston Ballet
http://www.arts-online.com/bostonballet

Brevard Community College
http://www.brevard.cc-fl.us/

Cambridge Multicultural Arts Center
http://www.arts-online.com/cmac.htm

Center For Electronic Art
http://www.cea.edu/

Cézanne, French Painter 1839-1906 *(Galleries Nationales du Grand Palais)*
http://cezanne.com/eng/accueil.htm

Christo and Jean-Claude
http://pomo.nbn.com/youcan/christo/

Clearinghouse: Arts and Entertainment
http://www.lib.umich.edu/chouse/tree/artent.html

Contemporary Art Site
http://www.tractor.com

Copyright Office
http://www.copyright.com

Dance Umbrella
http://www.arts-online.com/du.htm

DJ USA
http://www.djusa.com

Echo *(hosted by the Whitney Museum)*
http://www.echonyc.com

Edward Hopper
http://ucowww.usc.edu/~erics/art/hopper.html

Federal Express
http://www.fedex.com

File Room *(by Antonio Muntada)*
http://fileroom.aaup.uic.edu/FILEROOM.html.

Fine Art Forum Directory of Online Resources
http://www.msstate.edu/Fineart_Online/art-resources/index.html

Fluxus
http://www.panix.com/fluxus/

Galaxy Art
http://www.einet.net/galaxy/Humanities/Arts.html

Gallery Walk
http://www.ecn.bgu.edu/users/mfjfg/galwalk.html

Getty Art History Information Program
http://www.ahip.getty.edu/ahip/home.html

Information Cybernetics, Inc.
http://www.interactive.com

International Learning and Technology Center
http://www.arts-online.com/iltc/iltc.htm

Kandinsky
http://libra.caup.umich.edu/ArchieGopher/Kandinsky/Kandinsky.html

Leonardo da Vinci Museum
http://www.leonardo.net/main.html

Library of Congress
http://lcweb2.loc.gov/amhome.html

Margaret Giles's Hero and the Sublime Female Nude
http://www.stg.brown.edu/projects/hypertext/landow/cv/Chapters/Giles/
Giles_633.html

Massachusetts Institute of Technology (MIT)
http://www.mit.edu

Metropolitan Museum of Art
http://www.metmuseum.org/htmlfile/opening/enter.html

Microsoft Corporation
http://www.microsoft.com

National Association of Performing Artists Managers and Agents (NAPAMA)
http://www.napama.org

NETCOM On-Line Communications
http://www.netcom.com

Netscape Communications
> http://home.netscape.com

OTIS/SITO
> http://www.SITO.ORG

P-form
> http://fileroom.aaup.uic.edu/RSG/pformhomepage.html

Paintings of Vermeer
> http://www.ccsf.caltech.edu/~roy/vermeer/

Plexus
> http://www.plexus.org/

Rand Corporation
> http://www.rand.org

Rhombus
> http://www.together.net/~rhombus

Rotch Library
> http://nimrod.mit.edu/depts/rotch/services/rotch.html

Rotch Visual Collections
> http://nimrod.mit.edu/depts/rvc/

Sistine Chapel *(via Christus Rex Homepage)*
> http://christusrex.org/Surrealism

Smithsonian Places
> http://www.si.edu/organiza/start.htm

Surrealism
> http://pharmdec.wustl.edu/juju/surr/surrealism.html

The Thing *(web extension of the virtual art bulletin board)*
> http://www.thing.net/thingnyc

The World's First (and probably longest) Collaborative Sentence *(Douglas Davis and some 50,000 others)*
http://math240.lehman.cuny.edu/art

THAIS 12 Secoli di Scultura Italiana
http://www.thais.it/scultura/scultura.htm

Virtual Beret
http://www.rp.csiro.au/~pjordan/VirtualBeret/

Very Special Arts
http://www.vsarts.org

Waxweb *(by David Blair)*
http://bug.village.virginia.edu

Whitney Museum
http://www.echonyc.com/~whitney

World Wide Art Resources
http://www.concourse.com/wwar/default.html

Yahoo Arts
http://www.yahoo.com/Arts/

Zoe Helene
http://www.zoe-helene.com

911 Electronic Media Arts, Inc.
http://www.iquest.net/911/iq_911.html

INTERNET ACCESS via NETCOM

NETCOM On-Line Communication Services, Inc. is a leading international Internet service provider with years of network experience. Leveraging its own high speed nationwide TCP/IP based network, NETCOM provides a range of value-priced Internet services for individuals and businesses. NETCOM's complete Internet services offers a range of services including value pricing, software options, local access, and twenty-four-hour person-to-person customer support.

NETCOM offers NetCruiser and a complete Internet Kit, with everything you need to get on the Net. NETCOM provides many different services for dialup access. For individuals, NETCOM's Internet Kit provides you with software, guide books, e-mail, twenty-four-hour support, and value pricing at $19.95 per month for unlimited access. For the first month, you need only pay $5.

NETCOM On-line Communications, Inc. is located at 3031 Tisch Way, San Jose, CA 95128 and can be reached by phone at 800-353-6600. NETCOM's web site can be found at *http://www.netcom.com.*

VERY SPECIAL ARTS

Very Special Arts is an international organization that provides learning opportunities through the arts for people with disabilities, especially children and youths. Founded in 1974 by Jean Kennedy Smith as an affiliate to The John F. Kennedy Center for the Performing Arts, the organization offers programs in creative writing, dance, drama, music, and the visual arts.

Very Special Arts also maintains The Very Special Arts Gallery in Washington, DC. The gallery hosts emerging and professional artists with disabilities.

Very Special Arts programs are implemented through an extensive network of Very Special Arts state and international organizations. Each year, more than 1.5 million Americans participate in Very Special Arts programs in all fifty states, and hundreds of thousands more people are active in programs in over eighty other countries around the world.

Start with the Arts is an instructional program for four-, five-, and six-year-olds that uses the arts to assist young children, including those with disabilities, in exploring themes commonly taught in early childhood classrooms. The program develops basic literacy skills and offers engaging arts activities teachers can apply to all curricular areas.

Instructional materials are included for parents to continue their children's learning at home. Start with the Arts is being implemented in hundreds of classrooms across the country, providing creative learning opportunities through the arts.

The Very Special Arts Young Soloists Program annually recognizes out-standing young musicians with disabilities, ages twenty-five and under, who have exhibited exceptional talents as vocalists or instrumentalists. Each year, a committee of music professionals selects four award recipients to receive scholarship funds and perform at The John F. Kennedy Center for the Performing Arts. The Panasonic Young Soloists Award is generously sponsored by Matsushita Consumer Electronics Company, and the Rosemary Kennedy International Young Soloists Award is sponsored by the Kennedy Center Education Department through the Rosemary Kennedy Education Fund.

The New Visions Dance Project introduces people with disabilities to the art of dance and creative movement. Originally designed for youth with visual impairments, the project now involves people of all ages and with all types of disabilities in dance workshops and classes. As part of the project, professional dance instructors receive training in adaptive techniques for including students with disabilities in their classes. Originally developed in cooperation with the Alvin Ailey Dance Center, the program is implemented by dance companies, ballet schools, and recreational organizations throughout the country.

The Very Special Arts Native American Project provides opportunities for Native American children with disabilities to explore contemporary and traditional art forms. A collaborative effort between Very Special Arts and the Bureau of Indian Affairs, the program develops children's educational skills and artistic talents through a national Native American festival and artists residencies.

The VA/Very Special Arts Program provides veterans who receive care at VA medical centers with quality arts experiences through artist-in-residence programs and community-based activities. A collaborative effort between the Department of Veterans Affairs and Very Special Arts, this

rehabilitative program builds independence, self-confidence, and communication skills.

The Very Special Arts Institute is a studio art program focusing on creative dialogue and exchange. Each year, artists with disabilities from around the world are selected as Yamagata Fellows (named after visual artist and Very Special Arts supporter Hiro Yamagata) to spend a week together exchanging ideas and sharing adaptive techniques in the visual arts. The Institute culminates in a gallery exhibit of the artists' work and has been held at such prestigious locations as the Corcoran Gallery of Art in Washington, DC and the Royal Museum of Arts and History in Brussels, Belgium.

The Arts for Children in Hospitals program is designed to educate health care professionals about the important role of the arts as a communication tool with young patients. As part of this college-level course, medical students work side-by-side with their pediatric patients on art projects which build a trusting relationship and encourage children to talk about their hospital experiences. First piloted at Georgetown University School of Medicine, the program is now offered at medical and nursing schools across the country.

199 ◀

The Very Special Arts Young Playwrights Program was developed to introduce students to the art of writing for the stage. A Teachers' Guide provides creative writing and drama exercises for the classroom. Very Special Arts sponsors an annual call for entries, inviting students to submit original scripts addressing some aspect of disability in their themes. The final scripts are read by a distinguished Artists Selection Committee which selects up to two scripts for professional production at The John F. Kennedy Center for the Performing Arts in Washington, DC.

Very Special Arts Festivals are community-based celebrations that showcase participants in Very Special Arts programs across the United States. Festivals feature performances, art exhibitions, demonstrations, and educational workshops where children, youth, and adults with disabilities proudly share their artistic accomplishments. Very Special Arts Festivals are organized on the state and local level in collaboration

with schools, hospitals, recreation facilities, and other community organizations. An International Very Special Arts Festival is held every five years to spotlight programs and initiatives implemented by Very Special Arts affiliates worldwide.

The national headquarters of Very Special Arts is located at 1300 Connecticut Avenue, Suite 700, Washington, DC 20036. By phone, Very Special Arts can be reached at (800) 933-8721. By Internet, the Very Special Arts web site is accessible at *http://www.vsarts.org*.

ABOUT the AUTHOR

V. A. Shiva Ayyadurai is a designer, writer, scientist, entrepreneur, and educator. He comes from the worlds of art and technology. He is currently completing his doctoral work at the Massachusetts Institute of Technology (MIT) in Information Theory and Cybernetics. His experience spans the fields of visual studies, computer graphics, neuroscience, information retrieval, mechanical engineering, computer science, electrical engineering, business, and traditional as well as interactive marketing.

His graduate and undergraduate academic education reflects his training in both the arts and technology. He holds a master's degree in Visual Studies from the world-renowned MIT Media Laboratory. In addition, he holds another master's degree from the MIT School of Engineering in Mechanical Engineering. His undergraduate degree, also from MIT, is in Electrical Engineering and Computer Science. He has taught both graduate and undergraduate courses in the MIT Engineering School as well as the Sloan School of Management.

His scientific research has been in pattern recognition and classification of signals. He has used computer graphics and animation

techniques for the scientific visualization of data. In addition, Shiva has developed a new theory of information cybernetics, which seeks to unify a variety of diverse pattern recognition problems. He is recognized as a world authority on interactive marketing and has given lectures throughout the Unites States, Europe, and Asia. At the age of twelve, he developed one of the world's first electronic mail systems for which he was recognized by the Westinghouse Science Talent Search.

Shiva is also the founder, president and chief executive officer of Information Cybernetics, Inc. (ICI). ICI is dedicated to building advanced technologies and solutions for interactive media and works with Millennium Productions and Arts-Online.Com. which are subsidiaries of ICI. Millennium Productions is an art and technology company that combines visual design and technology to develop interactive productions on the Internet and on CD-ROM. Arts-Online.Com, at *http://www.arts-online.com/*, is the premier multi-arts cybervenue on the Internet offering resources, search engines, and advanced indexes for music, dance, theater, fashion, writing, photo-graphy, and visual arts.

Prior to starting ICI, Shiva worked for over fifteen years at such corporations as Hewlett-Packard, Lotus Development, Information Resources, and Number Nine. Through his work at these major corporations, he has consulted for such clients as Proctor and Gamble, Dun and Bradstreet, and many other multi-national corporations.

Shiva has a unique ability to communicate technology to both arts and non-arts audiences in a motivating and inspiring manner. He has spoken at major international and national conferences throughout the world.

INDEX

203 ◀

ALLWORTH BOOKS

Allworth Press publishes quality books to help creative individuals and small businesses. Titles include:

The Internet Publicity Guide by V. A. Shiva
(softcover, 6 × 9, 208 pages, $18.95)

The Photographer's Internet Handbook by Joe Farace
(softcover, 6 × 9, 208 pages, $18.95)

The Writer's Internet Handbook by Timothy K. Maloy
(softcover, 6 × 9, 208 pages, $18.95)

The Internet Research Guide by Timothy K. Maloy
(softcover, 6 × 9, 208 pages, $18.95)

The Business of Multimedia by Nina Schuyler
(softcover, 6 × 9, 240 pages, $19.95)

The Fine Artist's Guide to Marketing and Self-Promotion
by Julius Vitali (softcover, 6 × 9, 224 pages, $18.95)

How to Pitch and Promote Your Songs by Fred Koller
(softcover, 6 × 9, 192 pages, $18.95)

Legal Guide for the Visual Artist, Third Edition by Tad Crawford
(softcover, 8½ × 11, 256 pages, $19.95)

The Business of Being an Artist, Revised Edition by Daniel Grant
(softcover, 6 × 9, 272 pages, $18.95)

Artists Communities by the Alliance of Artists' Communities
(softcover, 6¾ × 10, 208 pages, $16.95)

Licensing Art & Design, Revised Edition by Caryn R. Leland
(softcover, 6 × 9, 128 pages, $16.95)

Business and Legal Forms for Fine Artists, Revised Edition
by Tad Crawford (softcover, 8½ × 11, 144 pages, $16.95)

The Artist's Complete Health and Safety Guide, Second Edition
by Monona Rossol (softcover, 6 × 9, 344 pages, $19.95)

Please write to request our free catalog. If you wish to order a book, send your check or money order to Allworth Press, 10 East 23rd Street, Suite 400, New York, NY 10010. Include $5 for shipping and handling for the first book ordered and $1 for each additional book. Ten dollars plus $1 for each additional book if ordering from Canada. New York State residents must add sales tax.

If you wish to see our catalog on the World Wide Web, you can find us at Millennium Production's Art and Technology Web site:

http://www.arts-online.com/allworth/home.html
or at **http://www.interport.net/~allworth**